Njideka Akunyili Crosby

I Refuse to be Invisible

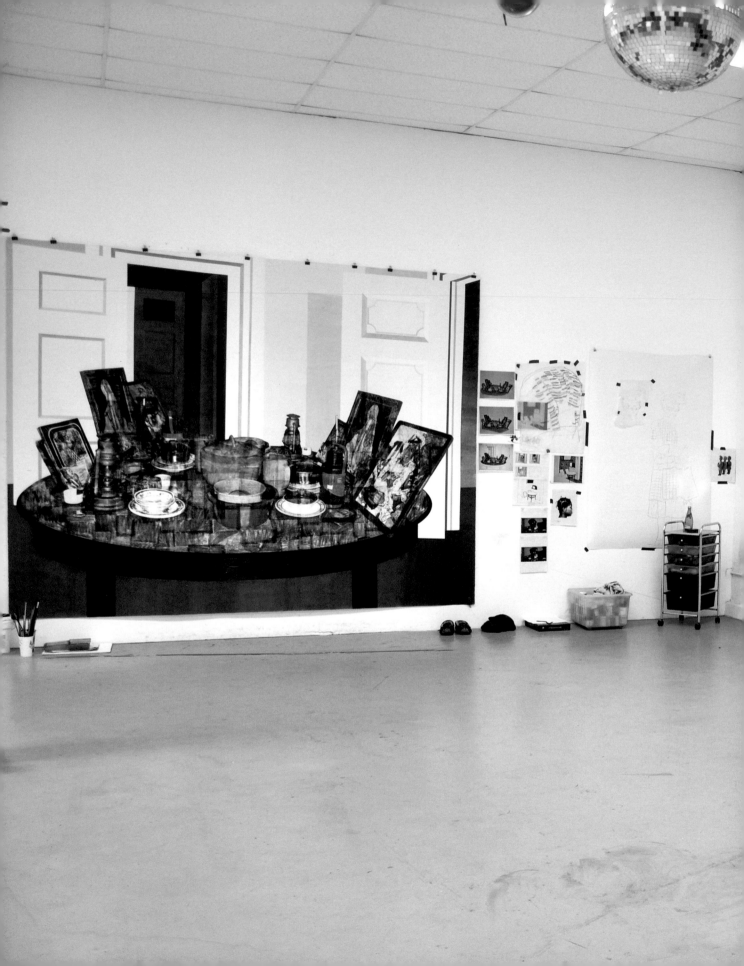

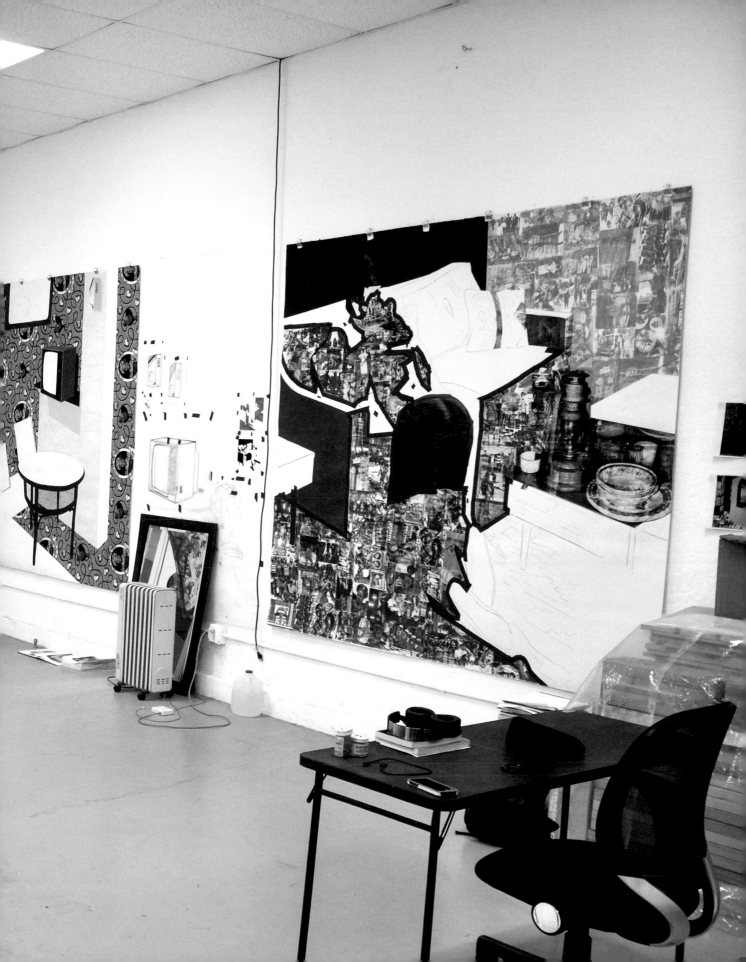

Njideka Akunyili Crosby

I Refuse to be Invisible

ORGANIZED BY CHERYL BRUTVAN

NORTON MUSEUM OF ART, WEST PALM BEACH, FLORIDA

Njideka Akunyili Crosby: I Refuse to be Invisible is the fifth exhibition of RAW—Recognition of Art by Women—made possible by the Leonard and Sophie Davis Fund/MLDauray Arts Initiative.

CONTENTS

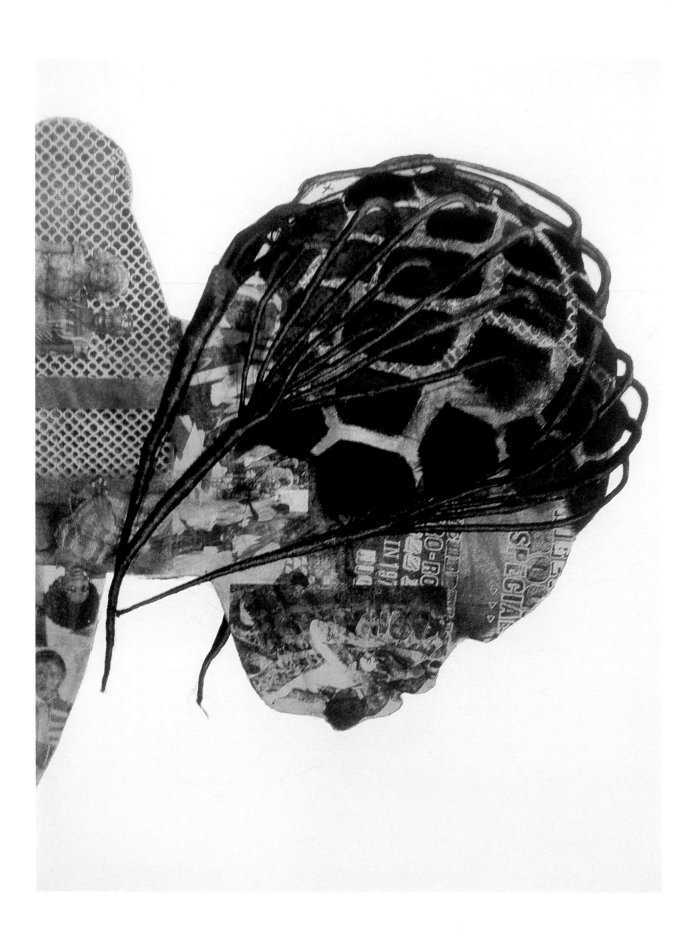

ACKNOWLEDGEMENTS

The Norton Museum is thrilled and proud to organize the first museum survey of the paintings of Njideka Akunyili Crosby as the fifth exhibition of our Recognition of Art by Women series. It is a rare opportunity to work with an artist at the moment she has realized her first mature body of work and is on the verge of wide critical recognition. I extend our great thanks to Njideka for participating in this exhibition and publication with enthusiasm and openness. She graciously welcomed Leonard and Sophie Davis Fellow Kristen Rudy, who was essential to the project's realization, and me to her Los Angeles studio. We also thank Njideka's studio assistant, Stephanie Deumer, for her help in coordinating this project.

We are grateful to Victoria Miro Gallery for their assistance and encouragement, especially Anna Fisher and Rachel Taylor. We also appreciate the support of Marianne Boesky Gallery, especially Ricky Manne and Serra Pradhan; the staffs at both Jack Tilton Gallery and Barbara Gladstone Gallery were also essential in securing important loaned works for this exhibition, and we thank them for their collaboration.

The exhibition would not be possible without the institutions and private collectors, who graciously agreed to lend their extraordinary examples of Njideka's work. We must thank the staff of the collectors and participating museums for making these essential loans possible. They have overcome obstacles to make challenging art available, rather than withholding it. In that vein, I must also acknowledge the efforts of Jamillah James, assistant curator of the Hammer Museum.

Each project at the Norton is wholeheartedly embraced by Executive Director Hope Alswang and Deputy Director James B. Hall. With their support, and the professionalism of the entire staff, this exhibition has come to successful fruition. We are grateful once again for the sensitive design of Bethany Johns, who created this publication, and to Wendy Bernstein, for her keen editorial assistance.

The RAW series has been realized through the dedicated philanthropy of Alan Davis and Mary Lou Dauray. Their transformative gift is also the expression of a sincere belief; it is their gift that has made possible the exhibitions and publications celebrating the work of five exceptional artists who are also women. We extend our profound thanks to such visionary donors.

Cheryl Brutvan
Director of Curatorial Affairs
Curator of Contemporary Art

(pages 2–3) The artist's studio, Los Angeles, CA, 2016
(page 4) *Nwantinti* (detail), 2012
(left) *Thread* (detail)

9

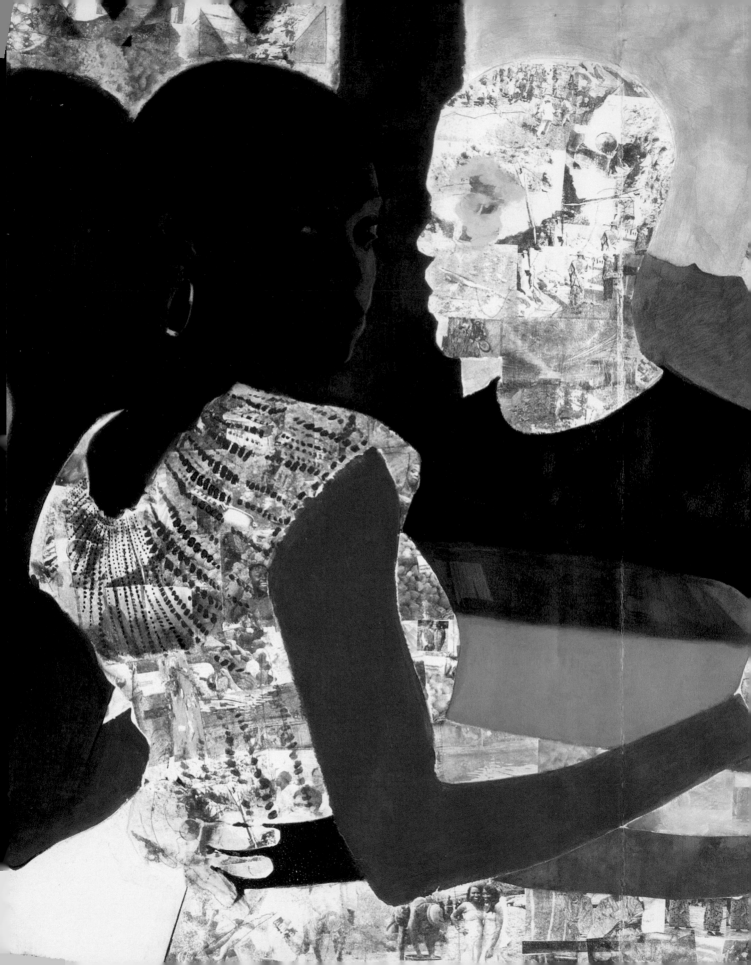

I Refuse to be Invisible

CHERYL BRUTVAN

Njideka Akunyili Crosby is a Nigerian-born, Los Angeles-based, Yale-educated artist whose biography inspires her work and reflects the life of some members of a generation of Africans no longer solely identified with one continent. She is an *Afropolitan,* as described in the following illuminating essay by Taiye Selasi, in the short stories and novels by Chimamanda Ngozi Adichie, and in some of the art comprising "All the World's Futures," organized by Okwui Enwezor for the 2015 Venice Biennale. The Afropolitan honors tradition and routines that evolved from economic, cultural, and geographic circumstances; the identity is manifested in hybrid versions of dress, food, language, and both obvious and subtle cultural references. It is a biography that, in part, reflects the evolution of every generation that has departed from one place for another. The ultimate creation is something unlike what was before, and expresses the resulting anxieties as well as the pleasure experienced in a new version of daily life. It is an experience that is personal and universal.

In the art of Akunyili Crosby, the Afropolitan identity is revealed in compositions created by an amalgam of processes. In a precise, linear style, the artist suggests narratives of familial settings and intimate relationships. The clothing or skin of characters, as well as architectural elements within her believable, domestic settings, are described using brilliant color and vibrant patterns, some of which she fabricates from the painstaking process of transferring hundreds of photographic images from their original source to the surface of her paintings. A calculated, formal element, this fabricated design can stand alone, evoking the visual power of decorative patterning masterfully integrated in the art of the French Nabi artists, for example, or in the collages and paintings of Romare Bearden (American, 1911–1988).

The effect takes on greater meaning for those familiar with Nigerian popular culture and politics. These dense, animated swaths comprise small images placed tightly next to each other, leaving no room between smiling faces of glamorous pop stars and models and despised dictators in uniforms, berets, and sunglasses. Occasionally, the images include the Akunyili family. The artist determines their arrangement in concert with her composition and its tone.

These collaged images play an important role in expanding Akunyili Crosby's representation of the distinct identity and environment of her world, and augment the ambiguous narrative of her scenes. In the 2012 painting *I Always Face You, Even When It Seems Otherwise* (pages 38–39), Akunyili Crosby offers a brief visual history of recent Nigerian politics through the selected images, read from right to left across this ambitious diptych. While the reference appears irrelevant to a scene occupied by figures around a table—including a couple conversing, or about to kiss—it is as if the artist uses this element to visualize another component in her compositions. The addition of something unseen and abstract is an "atmosphere" or thread of her DNA, not worn but integral to her identity. This distinct patterning distinguishes Akunyili Crosby's realism, which features depictions of seemingly unremarkable, comfortable relationships and environments. Couples are vulnerable and loving, groups of friends gather quietly together to talk, dance, simply live. The only branding is evident in African names for powdered milk and printed names on fabric. She avoids provocative poses and glances among her participants that might suggest an underlying emotional game, although the viewer must assimilate the juxtaposition of the images used to define her characters and interiors.

I Refuse to be Invisible (detail), 2010

Perhaps the deepest emotions in Akunyili Crosby's work are found in the still life or interior, such as *Tea Time in New Haven, Enugu* (pages 42–43) or the recent work *I See You in My Eyes* (page 61). In it the profound intensity of memories is realized through details—the table setting and wall cover—and the very absence of individuals except in framed photos. In the latter work, an extension of the room depicted in *I Still Face You* (page 58–59), Akunyili Crosby includes numerous references to her own history through transfers of family images placed along actual fabric that is printed in a pattern with the image of her mother, Professor Dora Akunyili.

Akunyili Crosby continues the long history in the arts of creating work based on what is known and seen; a preoccupation with the quotidian allows the artist to discover it as a resource for greater artistic challenges imbued with significant meaning. The history of Western art offers formal references for any artist interested in representation, and Akunyili Crosby has studied and embraced it, from Michelangelo's *Pieta* to Vuillard's patterned interiors. Her compositions are comprehensible, timeless spaces that reveal her understanding—even delight—in creating them. Her paintings are not simple renderings of fleeting moments in her life; they are the result of painstaking efforts and ambitious objectives. By virtue of their scale and use of multiple processes to illustrate her voice, Akunyili Crosby's works are inherently complex. While they appear believable, they are constructions of a preconceived composition that the artist fabricates through images of models, often using herself and her husband in multiple arrangements.

While numerous examples in the history of Western art illustrate artists' consistent focus on available subjects, it is critical to recognize that most of the figures in art—whether portraiture or genre—are white. Until the late 20th century, multiple narratives and differing perspectives, even that of women, have been largely ignored. Although her compositions formally reference art history, Akunyili Crosby recognizes its exclusive and extraordinarily limited representation of races. As a black African in America, she has chosen to share her world. The African-American artist Kerry James Marshall (below), whose work Akunyili Crosby greatly admires, articulated his own evolution to painting his reality, describing a view that is compatible with Akunyili Crosby's position. "All my life I've been expected to acknowledge the power and beauty of pictures made by white artists that have only white people in them; I think it's only reasonable to ask other people to do the same *vis-à-vis* paintings that have only black figures in them," Marshall says. "That is part of the counter-archive that I'm seeking to establish in my work. In fact, I would have to qualify

Kerry James Marshall (American, born 1955)
Study for "Untitled," 2014
Ink on paper
26 x 20 in. (66 x 50.8 cm)
Norton Museum of Art, Purchase, R.H. Norton Trust, 2015.79
© Kerry James Marshall. Courtesy of the artist and
Jack Shainman Gallery, New York

even that notion, as my work is not an argument *against* anything; it is an argument *for* something else."[1]

Unlike Marshall, Akunyili Crosby's primary point of reference is not that of the black experience layered with the contemporary and evolving repercussions from a history of people forced to voyage to another continent. She reacts, in part, to the abundance of stereotypes about Africans. The fact that too many Westerners, especially Americans, lack a basic knowledge about other parts of the world, along with an unfortunate reliance on the media's singular narrative, not only inspires Akunyili Crosby, but has compelled her and other artists of her generation to tell their own story. Well developed in literature, such representation in the visual arts is much less evident. In her critically acclaimed writing, author Chimamanda Ngozi Adichie (Nigerian, born 1977), a prominent voice in African literature, eloquently illuminates the experience of a generation of Africans in America and Europe. Adichie's work describes a reality that Akunyili Crosby finds remarkably similar to her own (they were born in the same city). Adichie's voice has been celebrated for its accessible and brilliant exposure of contemporary African life and, in fact, Akunyili Crosby has been referred to as the "Chimamanda of painting."[2] In the novel *Americanah* (2013), Adichie reveals the life of a young African woman who is fortunate to leave her beloved Nigerian home to pursue a college education in America. Through Adichie's wonderful prose, the reader is offered a view that few have imagined or even considered, when the character Ifemelu encounters such common concerns as struggling to survive economically as a student and falling in love.

The need to establish an African voice discussing Africa in the Western world, to counter the after-effects and misrepresentation of a formerly colonized continent, was only widely established in the mid-20th century. One of the first internationally known and critically successful writers of contemporary African literature was Chinua Achebe (Nigerian, 1930–2013), best known for his 1958 novel *Things Fall Apart*. Achebe was outspoken in his desire not to simply illustrate a reality unknown to the Western world, but to overcome the resulting repressive dynamic between those who define the other by being the only voice. Half a century later, the necessity to establish this voice remains; Akunyili Crosby promotes the effort by making rigorous and appealing paintings that are collected and exhibited internationally. The power of the arts to illuminate an unfamiliar world cannot be overestimated. The importance of this need, first proposed by Achebe, was articulated in a presentation by Chimamanda Ngozi Adichie titled "The Danger of a Single Story":

> ... after I had spent some years in the U.S. as an African (attending university), I began to understand my roommate's response to me. If I had not grown up in Nigeria, and if all I knew about Africa were from popular images, I too would think that Africa was a place of beautiful landscapes, beautiful animals, and incomprehensible people, fighting senseless wars, dying of poverty and AIDS, unable to speak for themselves and waiting to be saved by a kind, white foreigner.... This single story of Africa ultimately comes, I think, from Western literature.... A tradition of Sub-Saharan Africa as a place of negatives, of difference, of darkness, of people who, in the words of the wonderful poet Rudyard Kipling, are "half devil, half child."... I began to realize that my American roommate must have throughout her life seen and heard different versions of this single story....

> It is impossible to talk about the single story without talking about power. There is a word, an Igbo word, that I think about whenever I think about the power structures of the world, and it is *nkali*. It's a noun that loosely translates to "to be greater than another." Like our economic and political worlds,

stories too are defined by the principle of *nkali*: How they are told, who tells them, when they're told, how many stories are told, are really dependent on power….

The single story creates stereotypes, and the problem with stereotypes is not that they are untrue, but that they are incomplete. They make one story become the only story.[3]

I Refuse to be Invisible (page 33) is one of Akunyili Crosby's first mature paintings. The center of the composition shows a short-haired black woman, whose dress is covered in the artist's photo-based patterning, arm in arm with a man, whose skin is defined by the same pattern. He looks at her as she turns her head directly toward the viewer. Her features are barely perceptible. When asked if the title references African-American author Ralph Ellison's ground-breaking novel *Invisible Man* (1952), about the experience of blacks in America, Akyunyil Crosby acknowledges an indirect association. She recalls, "It just seems so relevant, that feeling of … invisibility that happens when you move here, and that happened to me when I moved here. That's why I think representation is so important, that feeling of: Do you exist if you don't see yourself? … On one hand, I refuse to be invisible—meaning I don't want to *not* exist due to the lack of representation."[4]

She continues, "I was thinking of painting this dark form that is doing a play with the painting, where this dark form goes through the whole piece and, from afar, the face of the girl blends into the background. So, it's just this dark into dark, and it seemed nebulous, like she *wasn't* clearly seen; but if you took time and came up to it and looked at it, she is *very* present, and regal, and proud, and clear. It's just on you, the viewer, to take the time to come closer and take a look at it."[5]

Come closer and take a look is both the conceptual premise that permeates Akunyili Crosby's art and its metaphorical subject. While this simple request should guide our relationship with all art—to stop and look, spend time and think about the very reason an artist made something for us to consider—it takes on even greater significance in the exceptional paintings of Akunyili Crosby, who gives voice and form to an ordinary and, paradoxically, unfamiliar world of a transplanted Nigerian woman in America.

1. Kerry James Marshall, "An Argument for Something Else: Dieter Roelstraete in Conversation with Kerry James Marshall, Chicago 2012," in *Kerry James Marshall: Painting and Other Stuff*, ed. Nav Haq (Antwerp: Ludion, 2013), 28.
2. Sam Umukoro, "Njideka Akunyili Crosby—Chimamanda of the Art World?" *Vanguard*, 9 November 2014.
3. Chimamanda Ngozi Adichie, *The danger of a single story,* TED Talk from TEDGlobal 2009, Oxford, England, July 23, 2009.
4. Njideka Akunyili Crosby, interview with the author, September 2015.
5. *Ibid.*

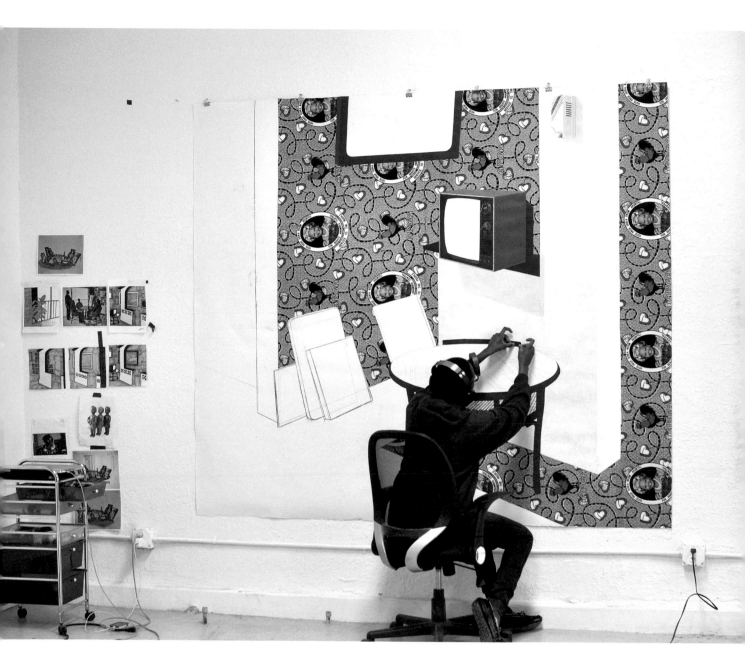

The artist in her studio, Los Angeles, CA, 2016

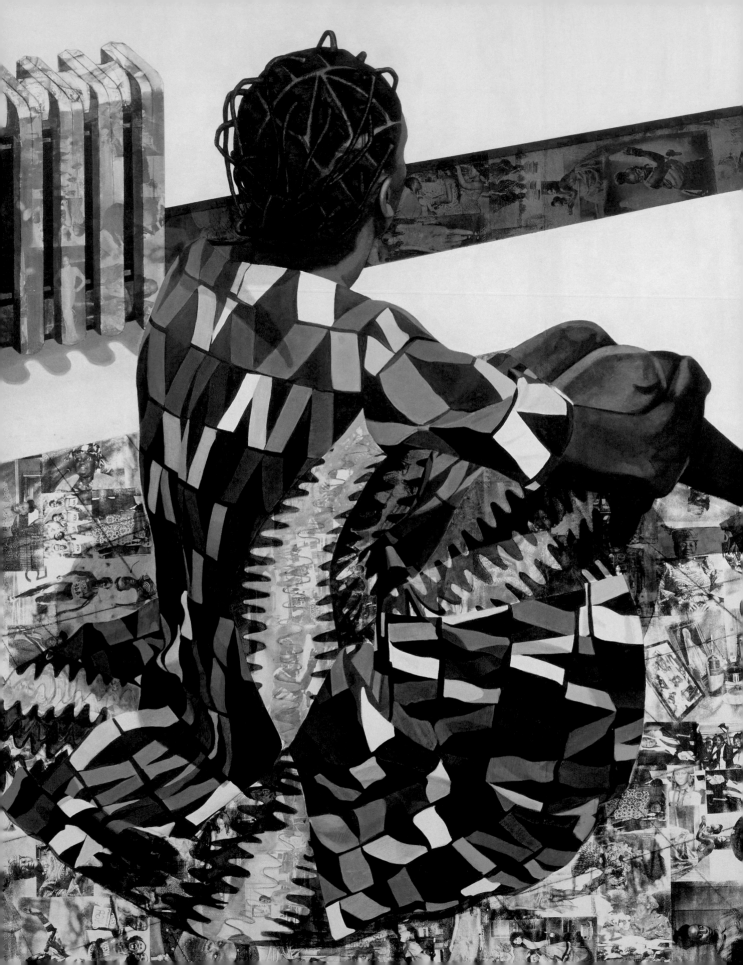

Bye-Bye, Babar (Or: What is an Afropolitan?)

TAIYE SELASI

It's moments to midnight on Thursday night at Medicine Bar in London. Zak, boy-genius DJ, is spinning a Fela Kuti remix. The little downstairs dancefloor swells with smiling, sweating men and women fusing hip-hop dance moves with a funky sort of djembe. The women show off enormous afros, tiny t-shirts, gaps in teeth; the men those incredible torsos unique to and common on African coastlines. The whole scene speaks of the Cultural Hybrid: kente cloth worn over low-waisted jeans; 'African Lady' over Ludacris bass lines; London meets Lagos meets Durban meets Dakar. Even the DJ is an ethnic fusion: Nigerian and Romanian; fair, fearless leader; bobbing his head as the crowd reacts to a sample of 'Sweet Mother.'

Were you to ask any of these beautiful, brown-skinned people that basic question—'where are you from?'—you'd get no single answer from a single smiling dancer. This one lives in London but was raised in Toronto and born in Accra; that one works in Lagos but grew up in Houston, Texas. 'Home' for this lot is many things: where their parents are from; where they go for vacation; where they went to school; where they see old friends; where they live (or live this year). Like so many African young people working and living in cities around the globe, they belong to no single geography, but feel at home in many.

They (read: we) are Afropolitans—the newest generation of African emigrants, coming soon or collected already at a law firm/chem lab/jazz lounge near you. You'll know us by our funny blend of London fashion, New York jargon, African ethics, and academic successes. Some of us are ethnic mixes, e.g. Ghanaian and Canadian, Nigerian and Swiss; others merely cultural mutts: American accent, European affect, African ethos. Most of us are multi-lingual: in addition to English and a Romantic or two, we understand some indigenous tongue and speak a few urban vernaculars. There is at least one place on The African Continent to which we tie our sense of self: be it a nation-state (Ethiopia), a city (Ibadan), or an auntie's kitchen. Then there's the G8 city or two (or three) that we know like the backs of our hands, and the various institutions that know us for our famed focus. We are Afropolitans: not citizens, but Africans of the world.

It isn't hard to trace our genealogy. Starting in the 60's, the young, gifted and broke left Africa in pursuit of higher education and happiness abroad. A study conducted in 1999 estimated that between 1960 and 1975 around 27,000 highly skilled Africans left the Continent for the West. Between 1975 and 1984, the number shot to 40,000 and then doubled again by 1987, representing about 30% of Africa's highly skilled manpower. Unsurprisingly, the most popular destinations for these emigrants included Canada, Britain, and the United States; but Cold War politics produced unlikely scholarship opportunities in Eastern Bloc countries like Poland, as well.

Some three decades later this scattered tribe of pharmacists, physicists, physicians (and the odd polygamist) has set up camp around the globe. The caricatures are familiar. The Nigerian physics professor with faux-Coogi sweater; the Kenyan marathonist with long legs and rolled r's; the heavy-set Gambian braiding hair in a house that smells of burnt Kanekalon. Even those unacquainted with synthetic extensions can conjure an image of the African immigrant with only the slightest of pop culture promptings: Eddie Murphy's 'Hello, Babar.'

"The Beautiful Ones Are Not Yet Born" Might Not Hold True For Much Longer (detail), 2013

But somewhere between the 1988 release of *Coming to America* and the 2001 crowning of a Nigerian Miss World, the general image of young Africans in the West transmorphed from goofy to gorgeous. Leaving off the painful question of cultural condescenscion in that beloved film, one wonders what happened in the years between Prince Akeem and Queen Agbani?

One answer is: adolescence. The Africans that left Africa between 1960 and 1975 had children, and most overseas. Some of us were bred on African shores then shipped to the West for higher education; others born in much colder climates and sent home for cultural re-indoctrination. Either way, we spent the 80's chasing after accolades, eating fufu at family parties, and listening to adults argue politics. By the turn of the century (the recent one), we were matching our parents in number of degrees, and/ or achieving things our 'people' in the grand sense only dreamed of. This new demographic—dispersed across Brixton, Bethesda, Boston, Berlin—has come of age in the 21st century, redefining what it means to be African. Where our parents sought safety in traditional professions like doctoring, lawyering, banking, engineering, we are branching into fields like media, politics, music, venture capital, design. Nor are we shy about expressing our African influences (such as they are) in our work. Artists such as Keziah Jones, *Trace* founder and editor Claude Gruzintsky, architect David Adjaye, novelist Chimamanda Adichie—all exemplify what Gruzintsky calls the '21st century African.'

What distinguishes this lot and its like (in the West and at home) is a willingness to complicate Africa— namely, to engage with, critique, and celebrate the parts of Africa that mean most to them. Perhaps what most typifies the Afropolitan consciousness is the refusal to oversimplify; the effort to understand what is ailing in Africa alongside the desire to honor what is wonderful, unique. Rather than essentialising

the geographical entity, we seek to comprehend the cultural complexity; to honor the intellectual and spiritual legacy; and to sustain our parents' cultures.

For us, being African must mean something. The media's portrayals (war, hunger) won't do. Neither will the New World trope of bumbling, blue-black doctor. Most of us grew up aware of 'being from' a blighted place, of having last names from countries which are linked to lack, corruption. Few of us escaped those nasty 'booty-scratcher' epithets, and fewer still that sense of shame when visting paternal villages. Whether we were ashamed of ourselves for not knowing more about our parents' culture, or ashamed of that culture for not being more 'advanced' can be unclear. What is manifest is the extent to which the modern adolescent African is tasked to forge a sense of self from wildly disparate sources. You'd never know it looking at those dapper lawyers in global firms, but most were once supremely self-conscious of being so 'in between.' Brown-skinned without a bedrock sense of 'blackness,' on the one hand; and often teased by African family members for 'acting white' on the other—the baby-Afropolitan can get what I call 'lost in transnation.'

Ultimately, the Afropolitan must form an identity along at least three dimensions: national, racial, cultural—with subtle tensions in between. While our parents can claim one country as home, we must define our relationship to the places we live; how British or American we are (or act) is in part a matter of affect. Often unconsciously, and over time, we choose which bits of a national identity (from passport to pronunciation) we internalize as central to our personalities. So, too, the way we see our race— whether black or biracial or none of the above—is a question of politics, rather than pigment; not all of us claim to be black. Often this relates to the way we were raised, whether proximate to other brown people (e.g. black Americans) or removed. Finally, how we

conceive of race will accord with where we locate ourselves in the history that produced 'blackness' and the political processes that continue to shape it.

Then there is that deep abyss of Culture, ill-defined at best. One must decide what comprises 'African culture' beyond pepper soup and filial piety. The project can be utterly baffling—whether one lives in an African country or not. But the process is enriching, in that it expands one's basic perspective on nation and selfhood. If nothing else, the Afropolitan knows that nothing is neatly black or white; that to 'be' anything is a matter of being sure of who you are uniquely. To 'be' Nigerian is to belong to a passionate nation; to be Yoruba, to be heir to a spiritual depth; to be American, to ascribe to a cultural breadth; to be British, to pass customs quickly. That is, this is what it means for me—and that is the Afropolitan privilege. The acceptance of complexity common to most African cultures is not lost on her prodigals. Without that intrinsically multi-dimensional thinking, we could not make sense of ourselves.

And if it all sounds a little self-congratulatory, a little 'aren't-we-the-coolest-damn-people-on-earth?'—I say: yes it is, necessarily. It is high time the African stood up. There is nothing perfect in this formulation; for all our Adjayes and Adichies, there is a brain drain back home. Most Afropolitans could serve Africa better in Africa than at Medicine Bar on Thursdays. To be fair, a fair number of African professionals are returning; and there is consciousness among the ones who remain, an acute awareness among this brood of too-cool-for-schools that there's work to be done. There are those among us who wonder to the point of weeping: where next, Africa? When will the scattered tribes return? When will the talent repatriate? What lifestyles await young professionals at home? How to invest in Africa's future? The prospects can seem grim at times. The answers aren't forthcoming. But if there was ever a group who could figure it out, it is this one, unafraid of the questions.

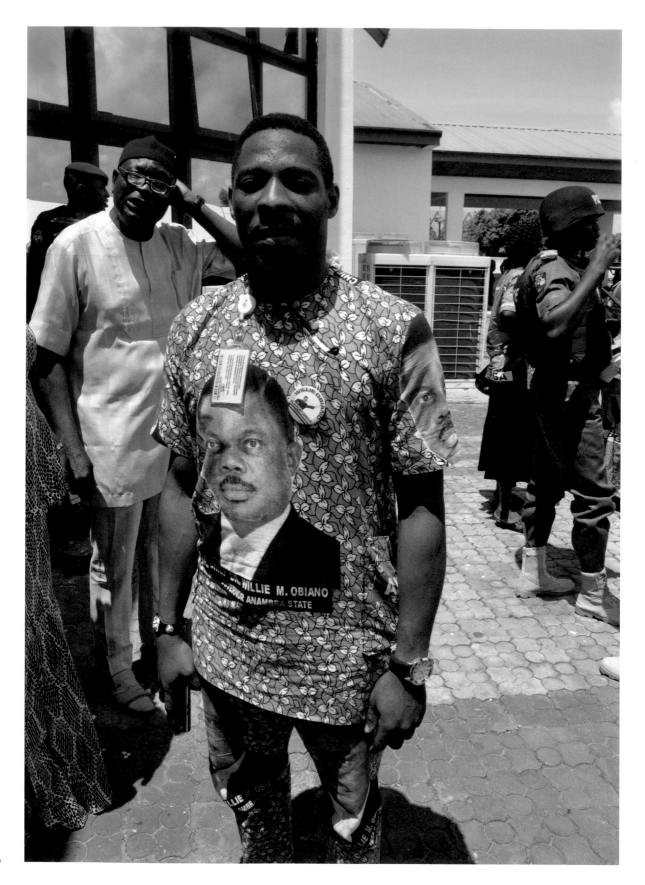

Interview with Njideka Akunyili Crosby

CHERYL BRUTVAN

Cheryl Brutvan: Tell me about your life in Nigeria.
Njideka Akunyili Crosby: I left Nigeria after high school. I grew up in a post-colonial country—it's this weird but exciting mash-up of different things. Even within the country, there are 200-plus tribes, and the cultures of all those tribes are beginning to mesh together. That's the reason I love using images of traditional weddings, which is one place where our tradition thrives. For example, at my brother's traditional wedding, they did something called *aso-ebi* ("cloth of the family"). Everyone gets the same fabric and sews their own pattern. It's a Yoruba custom, but it was an Igbo wedding; the headscarves were tied in a style from the Eastern part of the country, and the outfit designs were very Western—so it's just like this weird confluence. Even what people now call *tradition* is cobbled together from many things.

And, of course, Nigeria used to be a British colony, and even though independence was achieved [in 1960] before my formative years, my parents' generation went from being British protected citizens to Nigerian citizens. There are still a lot of vestiges of the British presence, and I try to look for pictures that speak to that. A very obvious one is that Nigerian lawyers still wear the white wig. All these practices feel normal to me; but now when I leave and come back, I'm able to see them more clearly. I love the idea of taking these things that were inherited and running with them and making them your own.

Another example is that we have a really big tea culture, but we do it in our own unique way—a British person wouldn't recognize it, but it's tea time!
CB: You have a painting titled *Tea Time in New Haven, Enugu* (pages 42–43).
NAC: Yes, it's based on a photograph I took of my grandmother's table the last time I went to her place

in the village. It was a couple years ago, 2013 maybe. I'm very into visual reading and I love these odd things that speak to a time or place or class. For me, something about it epitomizes Nigerian tables of a certain generation, a certain class, a certain place. Nigerians do this thing—not as much now, and not as much among rich people—but when I was growing up, the trend was to have a lot of stuff on your dining table, usually tea stuff. That's where this painting [*Tea Time in New Haven, Enugu,* 2013] comes from. You just leave the stuff there all day—the powdered milk, sugar, and chocolate powder. It's a way to show off that you own these, but it also serves as storage.

I like those odd things that different people do and consider normal, but are unique to that place or group. This photo shows what is particular to the village (Fig. 1)—it has all the plastic containers you use for water storage, cooking, serving. I also love the odd things like the kerosene lamp, which is standard in rural areas because the electricity is not reliable.

I'm fascinated by the brand of religion we practice in Nigeria, especially Catholics. There is always an

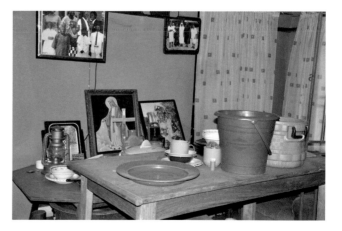

FIG. 1
Artist's grandmother's table, Agulu, Nigeria, 2012
Courtesy the artist

(facing) Outfit made from portrait fabrics, Awka, Nigeria, 2015
Courtesy the artist

image of Jesus somewhere, or the Sacred Heart, or Virgin Mary pictures. Growing up, we had a picture of Mary hugging an infant Jesus. The fascinating thing is that the same images were in the houses of many of our friends. I think like five stock pictures were sent to West Africa and everybody uses them. [*Pointing to the middle of the image from her grandmother's house:*] That same Jesus image is everywhere.

CB: [*Indicating another photograph within the same image:*] Is that a photograph of your grandmother?

NAC: Yes, the photograph is on her table. With the table, I like to create a weird combination so you end up in a no-man's land, where there is enough that different people will recognize, but also enough out of reach, that you don't quite have a full idea what's going on. You're not meant to really be clear where it is. To do that, I grasp all these visual reading cues and then I play with them. I create a space and a character and a situation that isn't quite easily put in a box. I'll do things like pair Ikea furniture, which I strongly associate with my American apartment, with the table from my grandmother's house, which has all these objects that are obviously not American, or from a Western developed country.

It's these weird jumps—it's almost like I want to put the viewer in this space of confluence, of multiple things—that I am interested in touching upon. It is this space where disparate elements come together, and the new space that comes out isn't just *this* plus *this*— it's like a whole new...

CB: It's another identity.

NAC: Yes. Which is a big topic in post-colonial theory with Homi Bhabha—the *third space* and *contact zones*. I'm doing it through my autobiography because it's something I innately understood and was interested in even before I started reading it. At first, I thought, "Oh my God, people have written about this, and I'm not crazy!" I remember taking my first post-colonial class, and it was like coming home. You know what you know—I've been aware of it my whole life—I just

didn't know other people knew about it and were writing about it. It helped me to know I wasn't alone, and to find words to talk about things I had always understood.

That's the thing with the third space: You recognize elements of *this* and *this*, but it's not quite anything you can wrap your head around anymore. With Nigeria, all the tribes mix in, and then the British presence, but then American pop culture starts coming in, like every other country in the world.

CB: What kind of references to America did you grow up with?

NAC: I grew up on Madonna, Michael Jackson, MC Hammer, *The Cosby Show, Sesame Street*. As Nigeria got rich and oil money started coming in, the country was able to purchase programs from the U.S., so that became part of the fabric of Nigerian life. Growing up, I could sense all that. In addition to the influence of foreign cultures in Nigeria, I also look at things like rural / urban differences through the lens of my autobiography. I grew up in a very small town where everybody knew each other; we used to go to the village for Christmas. Then I went to Lagos—a huge, cosmopolitan, fancy, fashion-forward city—for high school, and I had to make this huge jump and renegotiate a new space out of those two disparate things. Then I moved from Lagos to America.

One big theme that I explore a lot in my work is marrying my husband, because he becomes that which roots me in America. Of course home is Nigeria, and trying to think of these two notions of home and staying connected to both at once, and having to renegotiate, again, a new space for myself—a lot of those themes come out during the work.

And there are smaller things, like class. We grew up not very rich, but then my family got wealthy by the time I was in high school, so I was straddling both worlds and having to create this new space, so I often play with that in the female character. But these are things I wouldn't expect everyone to pick up—these

weird things that don't match up, that maybe, hopefully, a young Nigerian girl or someone from my generation would be able to pick out.

CB: Does the viewer have to know about Nigeria to understand your work?

NAC: No, that's fine. I feel like I am addressing a dual audience. I've existed in both worlds enough that I speak both, if that makes sense.

There's a lot of Nigeria in my work, but the paintings are rooted in a very Western tradition of image-making. All my painting training happened in the United States, most of it at the Pennsylvania Academy of the Fine Arts, so that is the tradition I am coming out of, that is what I've inherited. It's almost speaking these two languages at once. For me, it's like taking this tradition I've inherited and using it to talk about somewhere else, where this tradition did not evolve from. I'm thinking of what I need to do to what I've inherited, to make that happen.

That's why I love Chimamanda Ngozi Adichie and Chinua Achebe, because they address a dual audience; they write in English and use the local language and do not translate it for you.

CB: Chimamanda is an amazing writer and her novel, *Americanah,* helped me understand so much of your biography.

NAC: She gets it. She is so good at talking about my generation. I remember, years ago, my brother called because he had just read her collection of short stories, *The Thing Around Your Neck,* and he said he was crying. My brother is not someone who cries. I said, "It's not even a sad story," and he said, "Yes, but it just resonated so much." It was sincere, it took him back to growing up in Nigeria. She does that so well. A lot of Nigerian writers try, but there's just something about the sincerity that is hard to get, and not many people do it.

CB: Let's talk about some of the work. Who are the people in the *Beautyful Ones?* Are they people you know?

NAC: That series is slowly turning into a family portrait. The girl in glasses (page 53) is my parents' first child, my sister, when she was younger. The boy (Fig. 2) is the second born, my brother, when he was younger. And now she [*pointing to the unfinished painting, The Beautyful Ones, Series #4, 2015; page 55*] is the third born, my second sister, when she was younger. The one with the two kids (Fig. 3) is the first time I've done a piece with people I don't know at all or have no connection to. Usually it's family—a lot of Justin, my husband—and extended family depicted in my work. For the group compositions, when I work on the drawing and take photographs to help with the drawing, it's me and Justin posing in all the positions, then I invent and change out the faces.

CB: I love that it's a fiction.

NAC: But it's a fiction that could be true.

Going back to the *Beautyful Ones #3* (Fig. 3), I don't know the two kids, and they're seamed together from multiple pictures. Every time I go to Nigeria for events, I take lots of photographs. I had gone to a family friend's house during Christmas and had seen

FIG. 2
Njideka Akunyili Crosby
"The Beautyful Ones" Series #2, 2013
Acrylic, color pencils, pastel, and transfers on paper
Courtesy the artist

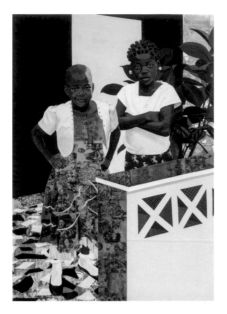

FIG. 3
"The Beautyful Ones" Series #3, 2014
Acrylic, colored pencils, collage, charcoal,
and transfers on paper
Courtesy the artist

those kids. I don't know them, but they really resonated with me because I recall my sisters and me rocking our "Christmas dress" (you got new clothes and not presents for Christmas) and feeling very proud of ourselves. I do that a lot when I choose pictures; there's a feeling of *I know this,* even though it's not me. That is how I felt about Chimamanda's characters— like, "I know this person!"

CB: What is the blue figure on the bench in the *Communion* image (page 55)?

NAC: That is a little doll I've been fascinated by. We all had it when we were young and played with it. It's like the cheap doll you had if you can't afford the dolls with hair. I remembered it recently and started researching it. We import a lot of things in Nigeria, so I just presumed it was produced either in Europe or China, but commissioned by a European country. Then I started researching it, and it's made by a Ghanaian company in Ghana. It's based off the wooden fertility *akuaba* dolls. It's fascinating because

it's this modern version of their traditional doll, but made to look like a Caucasian girl for African children to play with. I realized it's now a huge collector's item in Europe. Every once in a while I come across an object or picture that I feel really encapsulates how convoluted histories intertwine in countries that were a former colony.

CB: Well, that's what Yinka Shonibare is doing in fabric.

NAC: Exactly! I'm thinking of working more with portrait fabrics, because I find them exciting. Yinka Shonibare deals with Hollandais / Dutch wax fabric and its origin, but I'm actually interested in this other step, which is portrait fabrics.

CB: Yes, tell us, because I see this piece of fabric, and I see your surname here (*points to portrait fabrics*). (Fig. 4)

NAC: Oh, so that is from my brother's wedding. They come in five-yard pieces, so it is enough to make a full outfit. You commission like thousands of pieces for events, such as a wedding, campaign, birthdays, whatever you want. You don't have to, but a lot of people do. Weeks before the event, people start coming to your house and you give the fabric to them; they take it to the tailor and make outfits. It's similar to *aso-ebi,* where everybody wears the same patterned fabric. The next level is you can actually make your own portrait fabric and have everybody wear it.

CB: How incredible.

NAC: And the cool thing is, it becomes part of someone's wardrobe. (page 20)

NAC: This piece (*I See You In My Eyes,* page 61) is going to incorporate portrait fabrics; I have an idea, we'll see how it goes. I like it because Yinka Shonibare's work talks about how these fabrics, which are marks of African identity, are actually not made in Nigeria—they are from Europe—and that is one of the beautiful moments that shows this complicated history. But, something I like about the

portrait fabric is that we've taken this inherited thing that is not ours and co-opted it and done something to it that has made it our own. I can say portrait fabric is an African thing. It's not from Europe. When I lived in New York, I saw it in Harlem with Obama. Even *those* were being made in Kenya and shipped or being made by people who had seen it in some African country and are trying to re-create it. I feel like it's parallel to what I'm interested in doing in my art, and what I see being done in literature. I know it's something I want to come back and work with.

CB: The portraits are based on photography for the fabric. You use a lot of photography, too, don't you?

NAC: Yes, I do. I take a number of the pictures, but I find a lot online. Some are album covers that were popular when I was growing up. You see the guy with the Michael Jackson look a lot—that was a popular album cover when I was growing up. You see magazine covers, album covers, some historical events, like the queen's 1956 visit to Nigeria—you see the little kids waiting for the queen's car to drive by. I buy a bunch of magazines like this [*pulling out a copy of a Nigerian events magazine*] when I go home, but you can still get a lot of the pictures online.

CB: Did you start incorporating transfer images when you were at graduate school?

NAC: I started with just painting, and the introduction of the images was really slow. I remember in grad school, during studio visits I had fully worked paintings and drawings up on the wall and a ton of pictures on the floor—magazines and Nigerian images. The feedback I got from the professors was the things they saw on the floor seemed to be more in line with what they felt I was interested in. As time went on, it became clear to me that the images were a very important part of the work, even though I hadn't given them a chance, because I had a very specific idea of what painting should be.

I think that is why someone like Wangechi Mutu was such a big influence on me; sometimes it takes seeing someone's art to open up your mind and give you the freedom to do things.

CB: Because of her use of images and cut-outs?

NAC: Yes, and her ability to have an image composed of so many other images. Multiple images can exist on the same plane; it's about how you do it. That

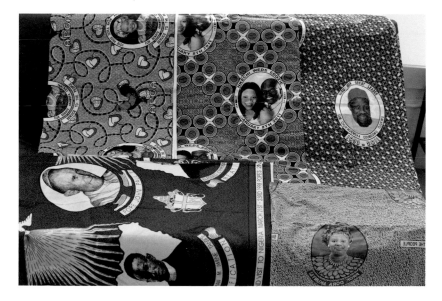

FIG. 4
Portrait fabrics
Courtesy the artist

made me realize I had a space for all these images to come into the works. I started working with collage; they were very simple, then got bigger and more complex, then I started painting and drawing into the collages. I got to the point where I felt like the cut-out collages were competing with the paintings, so I wanted them to exist on the same surface. I was trying to figure out how it would work, and transfers became the solution. So that's how it happened.

CB: Was that because you just didn't find the painting animated enough?

NAC: Yes, I just felt like painting wasn't enough. If you think of it as vocabulary, I needed more words. I had reached the limits of what I could do with the vocabulary of painting.

CB: Are you transferring all these individual images and you avoid making a pattern? That seems very labor intensive.

NAC: It is. I end up with a pile on the floor. Each one is individually done. So it's from the photocopy paper of the image, and I use acetone and rub the image onto the surface. You end up with a mirror image.

CB: So even though you're not drawing, you're spending a lot of time doing this.

NAC: Yes, a lot! It's very time consuming because it's not just about grabbing an image and putting it down. I have to make sure it lines up with the one before it.

CB: So it is like this printing process.

NAC: Yes, printmaking is huge in my world. I took printmaking with Rochelle Feinstein at Yale and I started doing silkscreen and monoprints. For me, it was the thought process of printmaking that had a lasting effect on my work process; it was something about the way the image was built, the layering and the pre-planning.

CB: Your painting style is very precise and linear.

NAC: It's almost like a very traditional way of painting, but bringing it to a mechanical age. A good friend of mine at Yale was using cut vinyl to make his paintings and getting all these sharp edges. He had a big influence on me, as a way to take what I was doing but use it in a way that says something about image making today.

I'm very interested in playing with the different languages of image making, which ties in to the content where I'm using printmaking, I'm using drawing, I'm using painting—but even within painting I'm using different types. I'm doing things that speak to gestural abstraction, things that speak to a Northern Renaissance painting, things that are more crudely painted.

CB: Your titles are so poetic; can you discuss their significance, and whether there is a relationship between the title and the images you choose?

NAC: For some works, there is a very clear connection with the images, but sometimes it's not as clear. With *Nwantinti* (2012, pages 48–49), I wanted a red dominant work so I looked for pictures that were red and also things with a musical theme. It makes sense to me. The title *Nwantinti* comes from a song called "Love Nwantinti" (with a red album cover) that was very popular when I was growing up. That's what you say to tease people who are being cheesy with their love. It's one of those songs lots of people know.

With this I wanted to try something else; I wanted to see if someone who knew the cues could see and read the title and a song would start playing in their

FIG. 5
Artist's studio, Los Angeles, 2015
Courtesy the artist

head. I wondered, "Can I evoke this song in their head?" I didn't want to call it *Love Nwantinti* because it was a bit too much. I didn't want to use the word *love* because the work is romantic; I tried to downplay that a bit, so it's just *Nwantinti*. My work uses a lot of musical references; there are lots of album covers, lots of Nigerian musicians, images from *Nigerian Idol*.

CB: What about *The Beautyful Ones*? What is that a reference to?

NAC: There is a book that was very popular, read in all the high schools—not just in Nigeria but probably Ghana as well, because it's a Ghanaian book. The title is *The Beautyful Ones Are Not Yet Born*, and it was a big part of the oeuvre of Nigerian literature. It was written by a Ghanaian guy, Ayi Kwei Armah, in the '70s.

In the '60s in West Africa there was a wave of independence. Nigeria became independent in 1960, and I think it was a very promising time—*hopeful* is the word—so lots of people had hope: meaning, "OK, now we're on our own, we're ready to show people what we can do, things will be great and fantastic." The decade went by and, sadly, none of that happened. There was rampant corruption; countries were going downhill instead of getting better.

This book was written during this time, really lamenting the lost hope of that generation, how things didn't work out. That's *The Beautyful Ones Are Not Yet Born*.

With the *Beautyful Ones* series, it was coincidence that it ended up being most of my family members. I was thinking, "If the Beautyful Ones were not yet born in the '60s or '70s—slightly after my parents' generation—hopefully they are in my generation." Fingers crossed. So that's why these are the Beautyful Ones. It's a play that hopefully Africans who know the book will pick up on.

A while ago there was a group show in Berlin (curated by Storm Janse van Rensburg) for a number of contemporary African artists, and the title was *The Beautyful Ones*, so I thought, "Yes, this must be a very common book."

In *"The Beautyful Ones Are Not Yet Born" Might Not Hold True For Much Longer* (pages 50–51), the images are all women—the power women in Nigeria right now who are making a lot of change. Chimamanda is in it; Asa, who is one of our star musicians, is in it; Genevieve, the actress; some soccer players; Okonjo-Iweala, the former vice president of World Bank and Nigerian Minister of Finance, is in it; my little sister, who I think is a rock star, is in it. So this is a lot of power women.

CB: So you were very conscious of what you were putting in, in terms of transfers. It seems like there is often a relationship, but is it important for everyone to understand or recognize these images?

NAC: No, it's me having fun. I feel like they exist as paintings and you can pick things out; some things are quite easy to pick out, and the ones that are not are still pictures that show life in another place in a way that is important and relevant.

CB: Didn't you say that in one of the works the images were quite historical and chronological?

NAC: Yes, *I Always Face You, Even When It Seems Otherwise* (pages 38–39; Fig. 6). The way it came about is a little bit long. I was reading Chinua Achebe's *No Longer At Ease*. The main character is an Igbo guy who was going abroad for school, so the whole community donated money to send him to England. Right before he left, there was a meeting where they were going to say farewell and give him advice.

A lot of the advice that started going around was: Don't come back with a foreigner. They were trying to explain why you shouldn't marry a foreigner—they're going to leave you, it never lasts—and finally a guy got up. He was the wise man of the village, and it was his turn to summarize everything. So he said the problem with marrying a foreigner isn't that they'll leave you; the problem is that when they're with you,

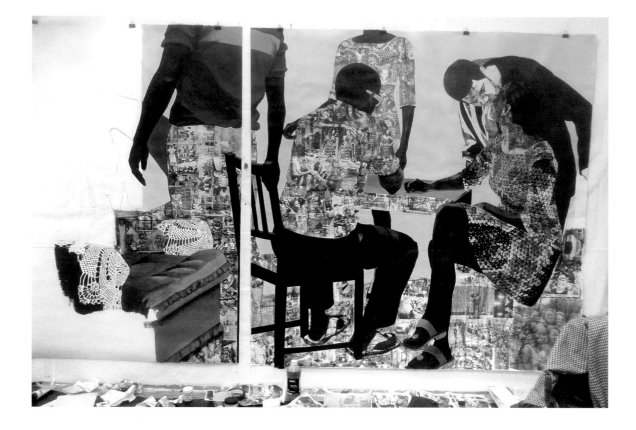

FIG. 6
I Always Face You Even When It Seems Otherwise,
in progress, 2012
Courtesy the artist

they'll make you turn your back on your kinsmen.

That really hit at the anxiety I had felt around my marriage to Justin—this feeling that *you will leave us if you marry outside*, especially because the culture passes through men. It's as if my children will not be considered Igbo—I'm not really considered part of my extended family/village anymore. It's almost like making the choice to divorce yourself from your culture.

I feel like I touch upon that in a number of the works—in this one, too. I was doing a play on facing two directions at once—I'm facing my husband, but my body and legs and everything else are facing everyone else. I was thinking of this as my people or my kinsmen. This is chronological, where I was thinking of the right panel as being now, and it slowly moves into the past, the left panel.

So I arranged the transfer images chronologically. I'll just point out a few: This black-and-white picture in the far left, the guy in the black cap, Nnamdi Azikiwe, fought for Nigeria's independence. He's important to Igbos because he's considered one of the main figures of Nigerian nationalism. It's hard to see, but there's a picture here that has Odumegwu Ojukwu. Nigeria had a big civil war in the late '60s. Eastern Nigeria, which is where I'm from, was trying to break away from the rest of Nigeria and be its own country, Biafra. They lost. Ojukwu led the Biafran civil war. He would've been the president of Biafra. People still call him the father of the Igbo people. There's also an image of the Igbo Ukwu pot, which is

one of the oldest artifacts ever found in Eastern Nigeria. There's a guy here [*pointing to another image*] who is a very popular actor—Pete Edochie; when I was small, the local station did a soap opera of *Things Fall Apart,* and he played Okonkwo, who is like the quintessential Igbo man. So lots of little things like that—old pictures from Eastern Nigeria— those are the kind of things I set out for myself when I'm looking for pictures.

CB: And then it still reads as this great composition.

NAC: And it's fun because I get to spend hours online.

CB: Earlier we were talking about the differences in the generations between you and your parents.

NAC: Thinking about the different generations—during my grandparents' generation, lots of them lived and died in the village. Most didn't speak English. In my parents' generation, the dream was to make a better life, which involved leaving the village, going to the city, going to a missionary school or—if you could, it was rare back then—going out of the country. Being Anglicized was parallel to being a better-educated person, a more upper-class person. So a lot of people left the village and moved to the cities; most people didn't go back as much. In my generation, there's a move back to tradition, but it's a very hybrid, cobbled tradition because things have already been lost. We're mixing things left over from different parts of the country to get a new tradition, but it's a new thing, it's constantly evolving. It's sad, but it's also beautiful at the same time. It's interesting and unique.

CB: We talked earlier about the images of Nigeria, the images that resonated with you, but also this complete political connection through your mother and father and that generation. Does that enter your art?

NAC: I don't always have to do something that is clearly about politics, or about religion in Nigeria, because you can't run away from them. They will always seep in somehow, because they're such a big part of life. In Nigeria, we had military dictatorships for most of my life, up until Sani Abacha [military president of Nigeria from 1993 to 1998] died in 1998. It was the thing everybody talked about, it was on TV all the time, every newspaper headline, it slowly filtered in.

I'm Nigerian; I grew up under too many dictator-ships, but I think that *coup* is a word I have in my head about my art. It's subtle and slips in there before you even know, so it turns out the image is changing your perception of a place before you even know what is happening. But *political* can refer to things beyond the government. I'm thinking of images I didn't see, but I wanted to see more—thinking of a woman of color and a white man in a very loving inti-mate relationship, being depicted in a very ordinary way; this is a power structure that is different from what I've seen before.

From the author's conversations with the artist, Los Angeles, summer 2015

Works in the Exhibition

I Refuse to be Invisible, 2010
Ink, charcoal, acrylic, and transfers on paper
120 x 84 in. (304.8 x 213.4 cm)

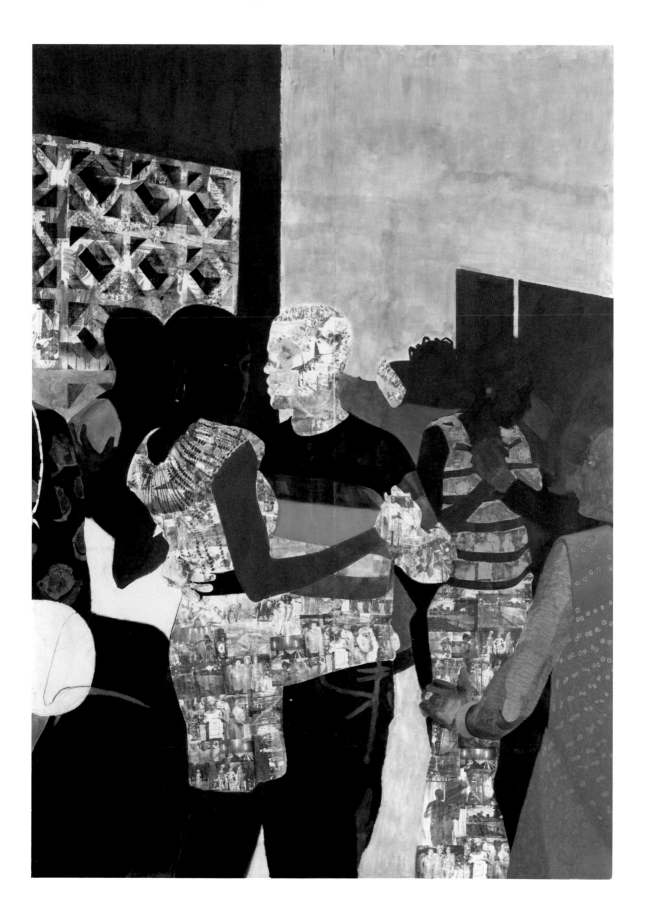

Janded, 2012
Acrylic, oil, and collage on canvas
24 x 20 in. (61 x 50.8 cm)

For Services – Victoria Regina, 2013
Oil, acrylic, and collage on canvas
24 x 20 in. (61 x 50.8 cm)

Sisi eko, 2015
Acrylic and oil on panel
24 x 20 in. (61 x 50.8 cm)

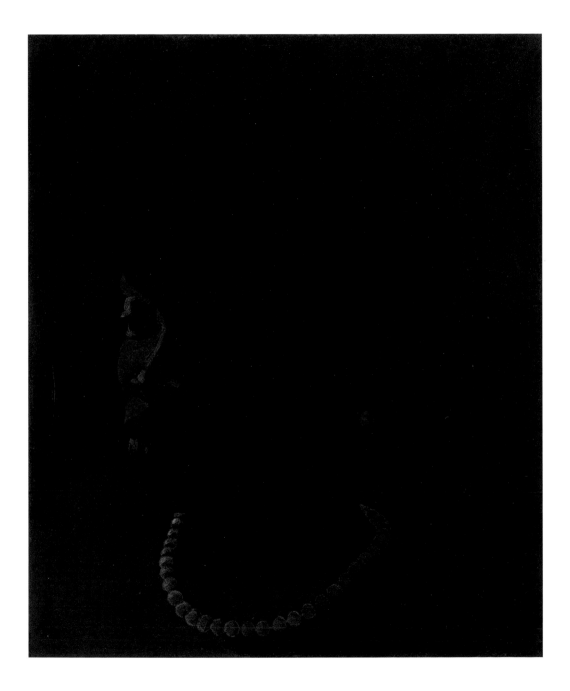

I Always Face You, Even When It Seems Otherwise, 2012
Charcoal, acrylic, and transfers on paper
2 panels, each 78 x 78 in. (198.12 x 198.12 cm)

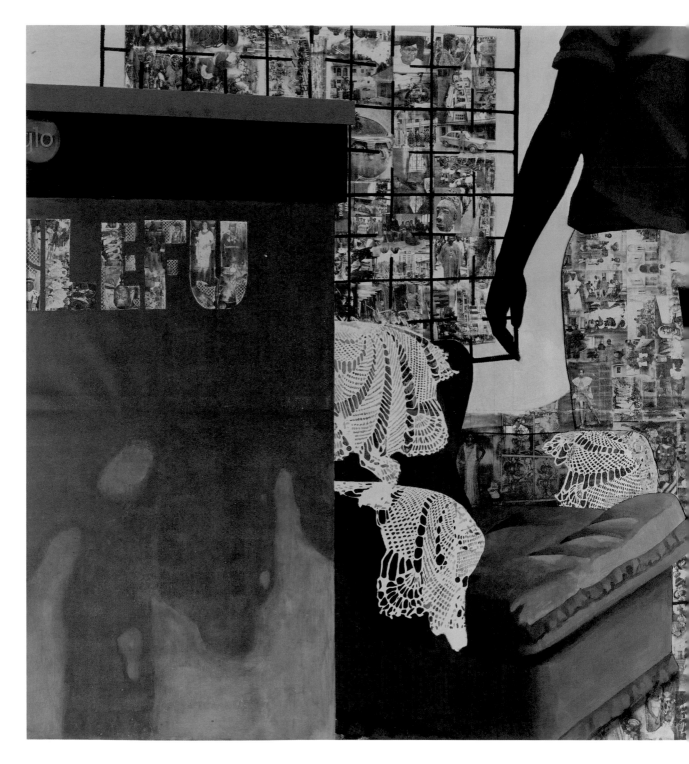

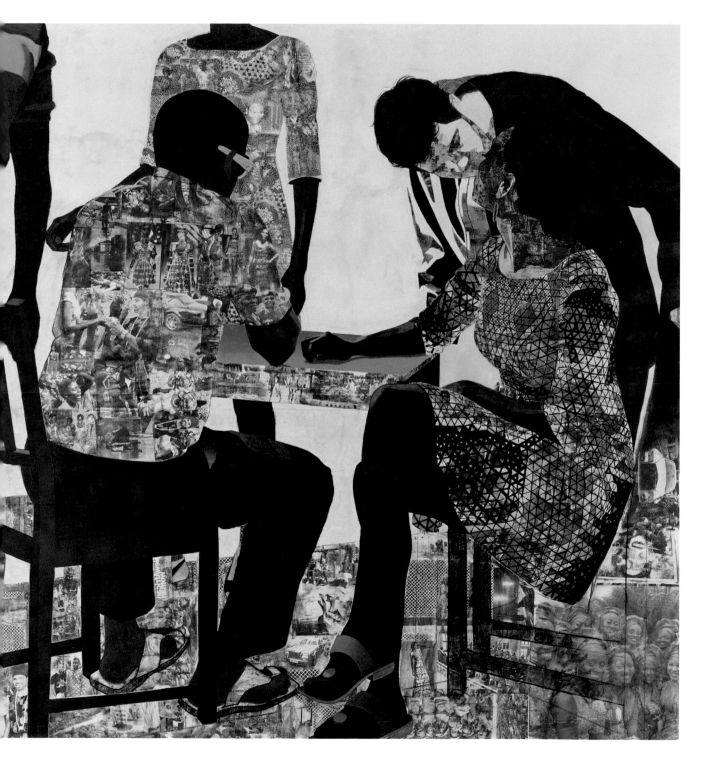

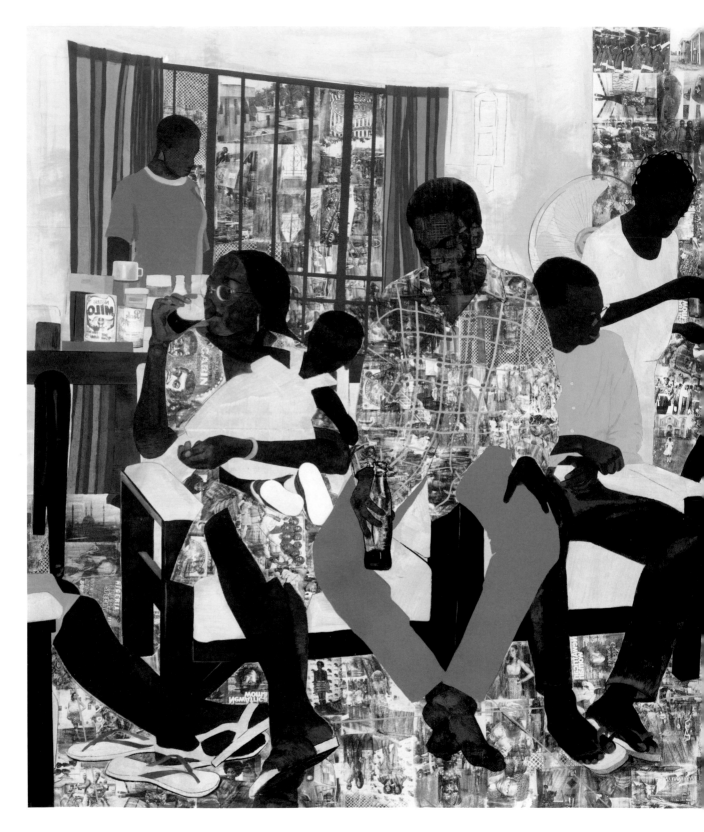

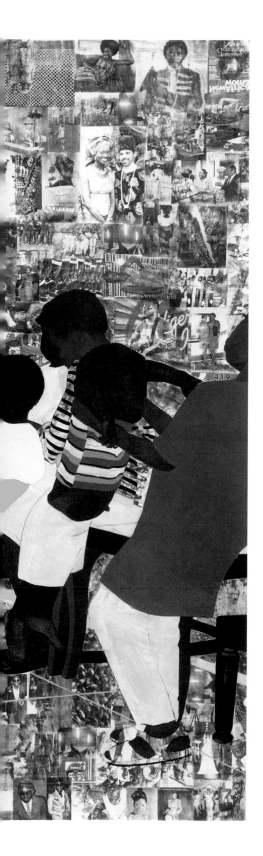

5 Umezebi Street, New Haven, Enugu, 2012
Acrylic, charcoal, pastel, colored pencils,
and transfers on paper
84 x 105 in. (213.4 x 266.7 cm)

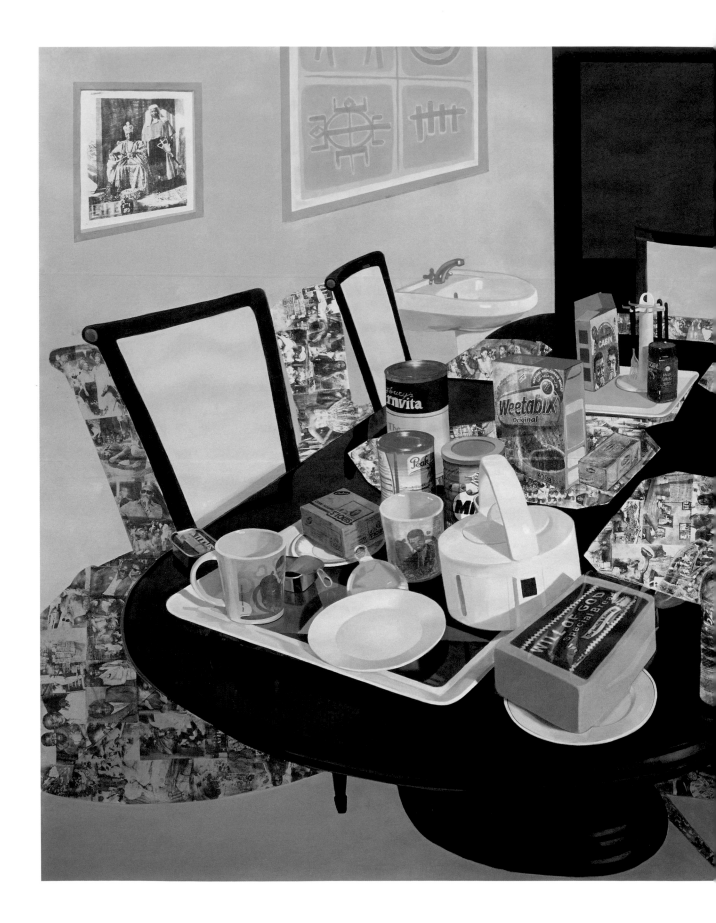

Tea Time in New Haven, Enugu, 2013
Acrylic, collage, colored pencils, charcoal,
and transfers on paper
84 x 111 in. (213.4 x 281.9 cm)

Nyado: The Thing Around Her Neck, 2011
Charcoal, acrylic, colored pencils, lace,
collage, and transfers on paper
84 x 84 in. (213.4 x 213.4 cm)

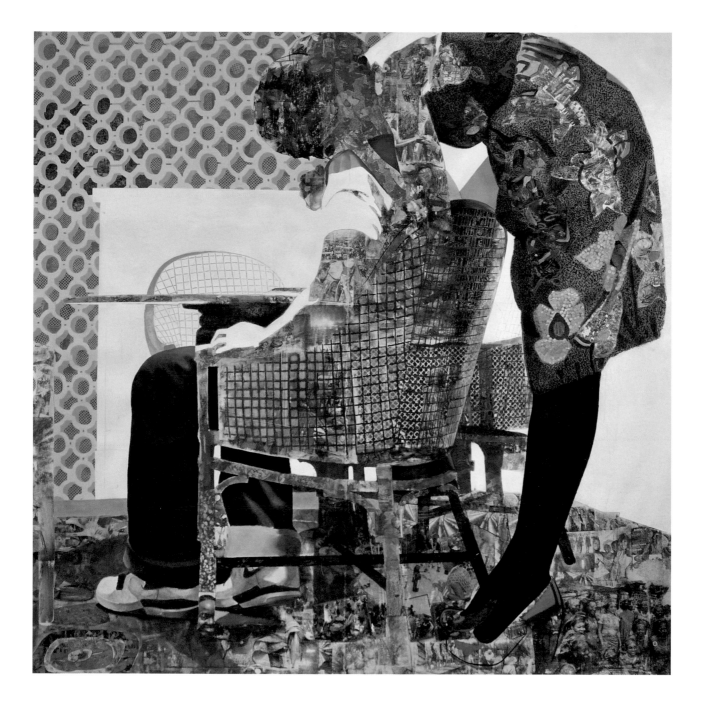

Thread, 2012
Acrylic, charcoal, pastel, colored pencils,
and transfers on paper
52 x 52 in. (132 x 132 cm)

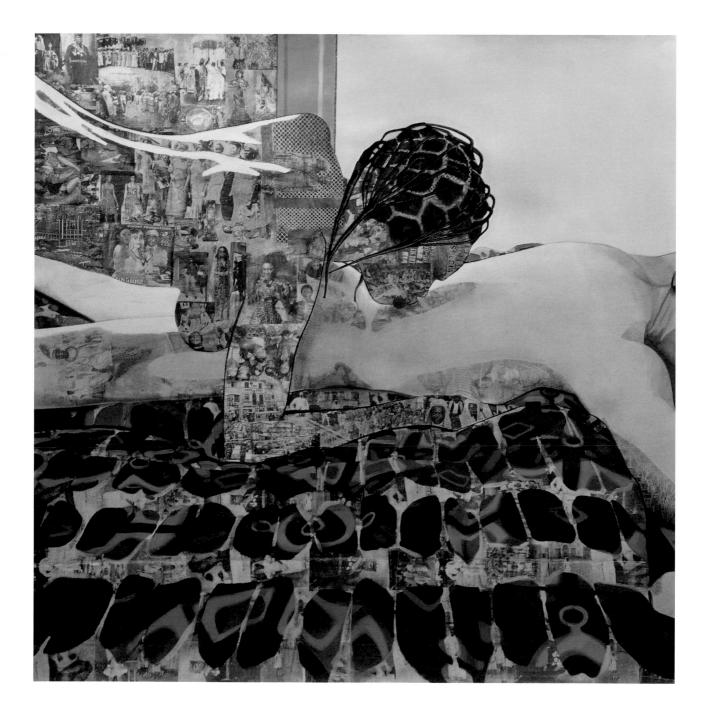

Nwantinti, 2012
Acrylic, charcoal, colored pencils, collage,
and transfers on paper
68 x 96 in. (172.7 x 243.8 cm)

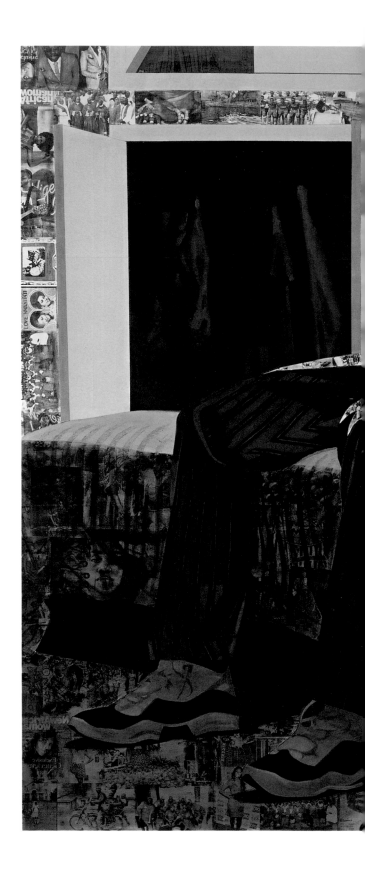

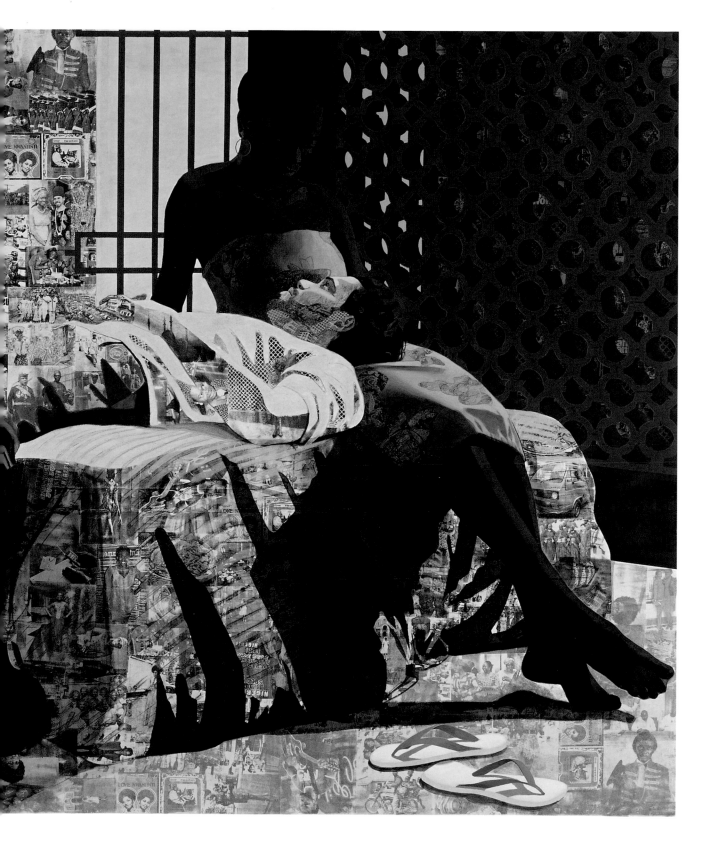

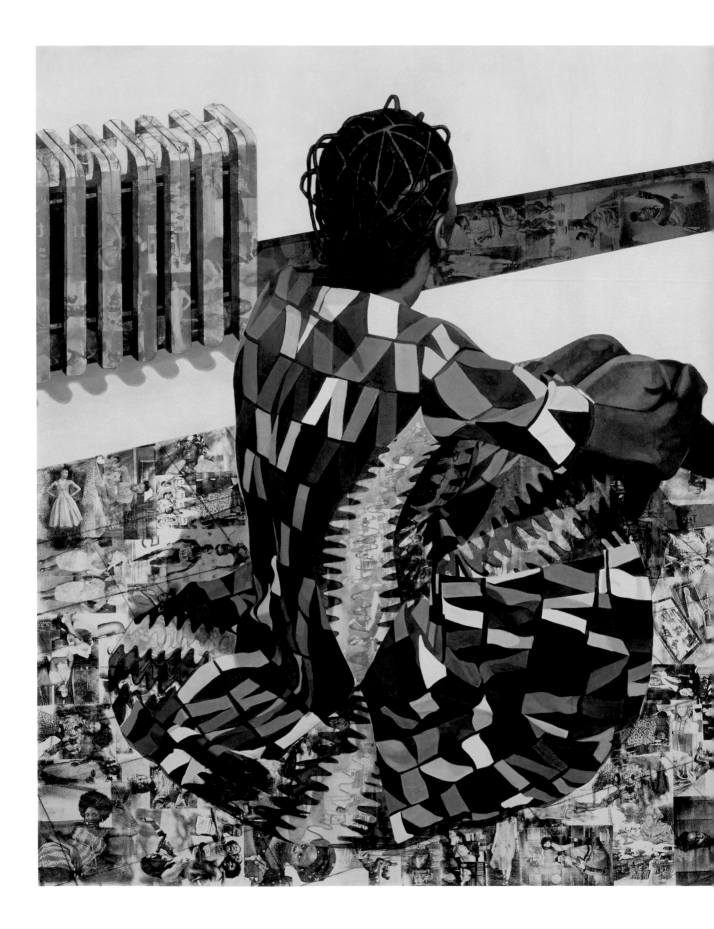

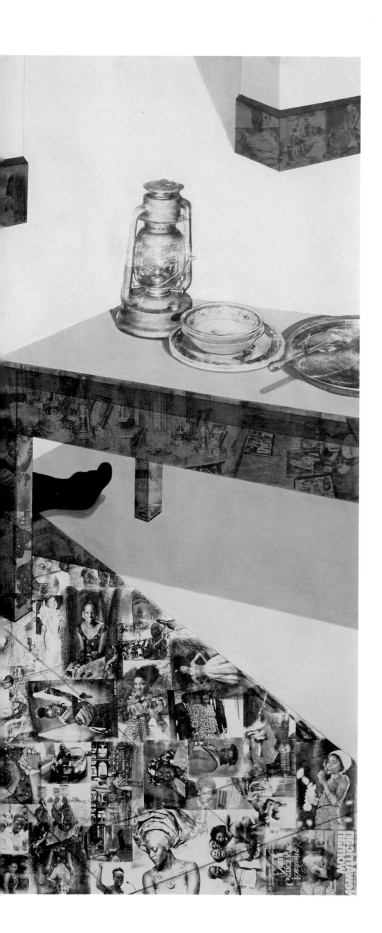

"The Beautyful Ones Are Not Yet Born"
Might Not Hold True For Much Longer, 2013
Acrylic and transfers on paper
64 x 82 7/8 in. (162.6 x 210.5 cm)

"The Beautyful Ones" Series #1c, 2014
 Acrylic, colored pencils, and transfers on paper
 61 x 42 in. (154.9 x 106.7 cm)

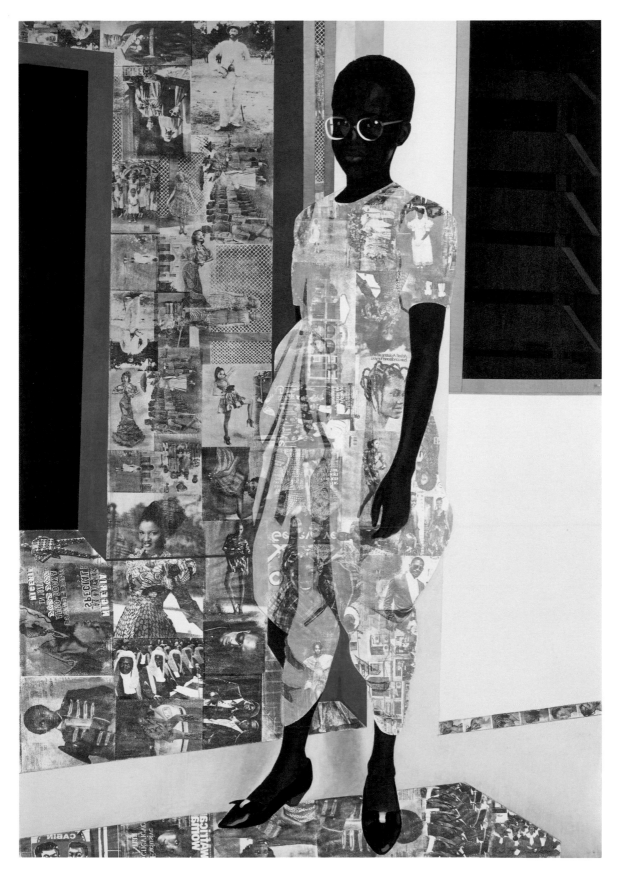

"The Beautyful Ones" Series #4, 2015
 Acrylic, colored pencils, and transfers on paper
 61 x 42 in. (154.9 x 106.7 cm)

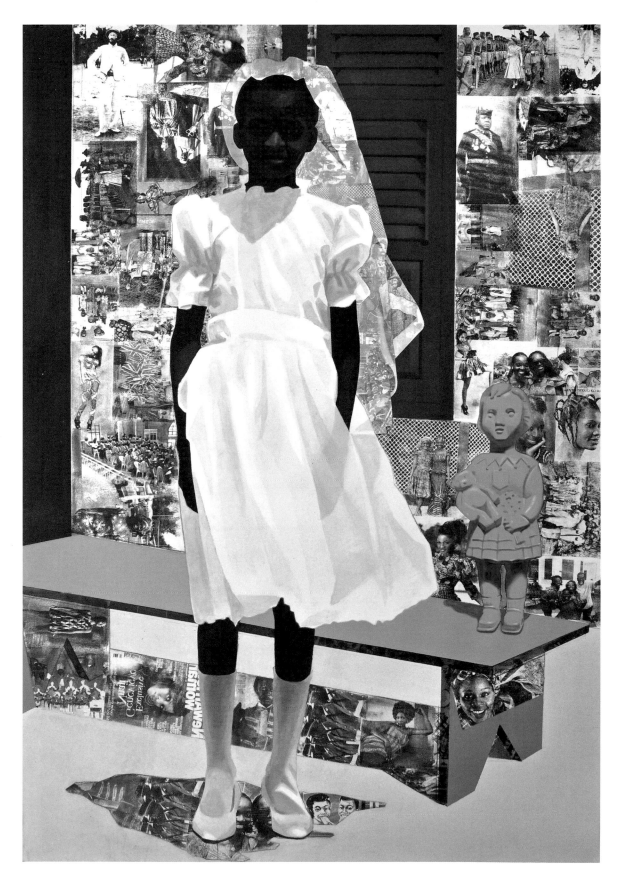

Bush Girl, 2015
Acrylic, colored pencils, and transfers on paper
84 x 84 in. (213.4 x 213.4 cm)

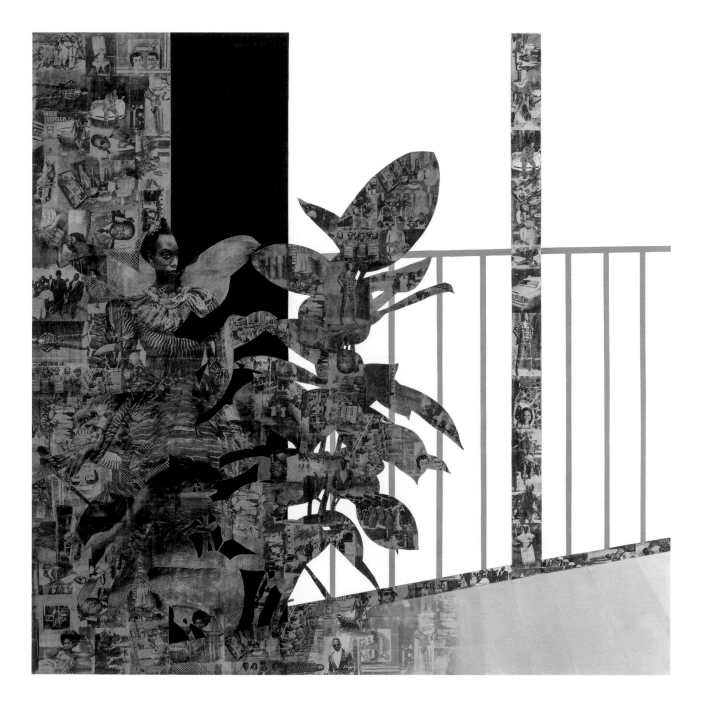

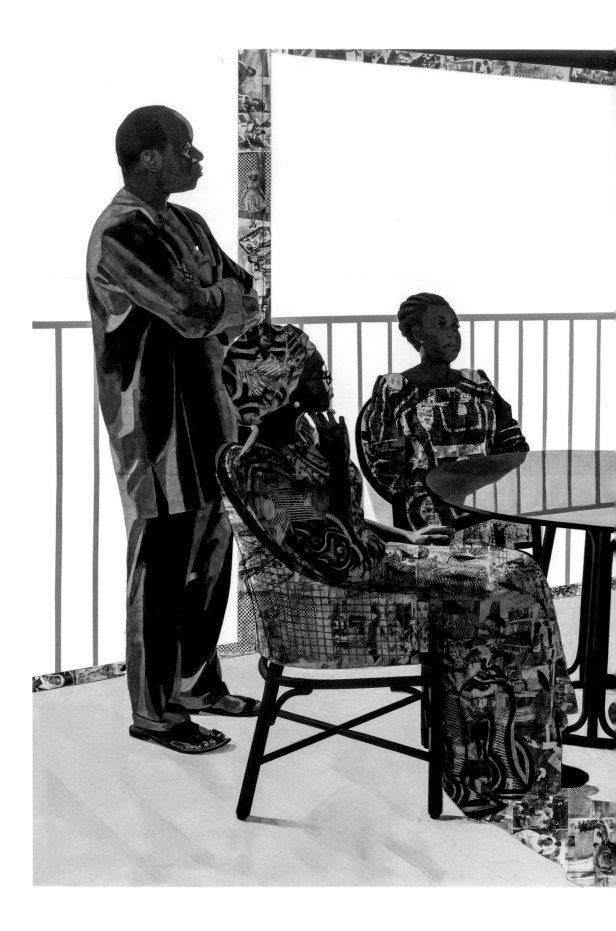

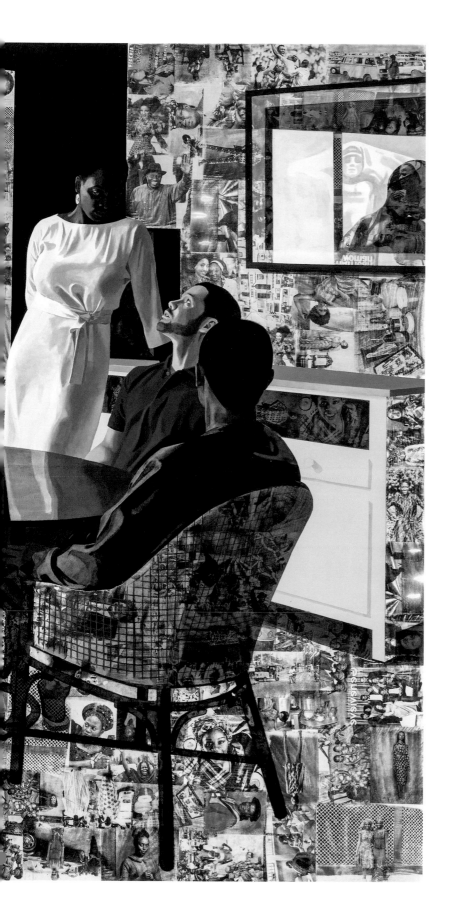

I Still Face You, 2015
Acrylic, colored pencils, charcoal, oil,
and transfers on paper
83 1/4 x 104 3/4 in. (211.5 x 266.1 cm)

I See You In My Eyes, 2015
Acrylic, transfers, colored pencils, collage,
and commemorative fabric on paper
84 x 84 in. (213.4 x 213.4 cm)

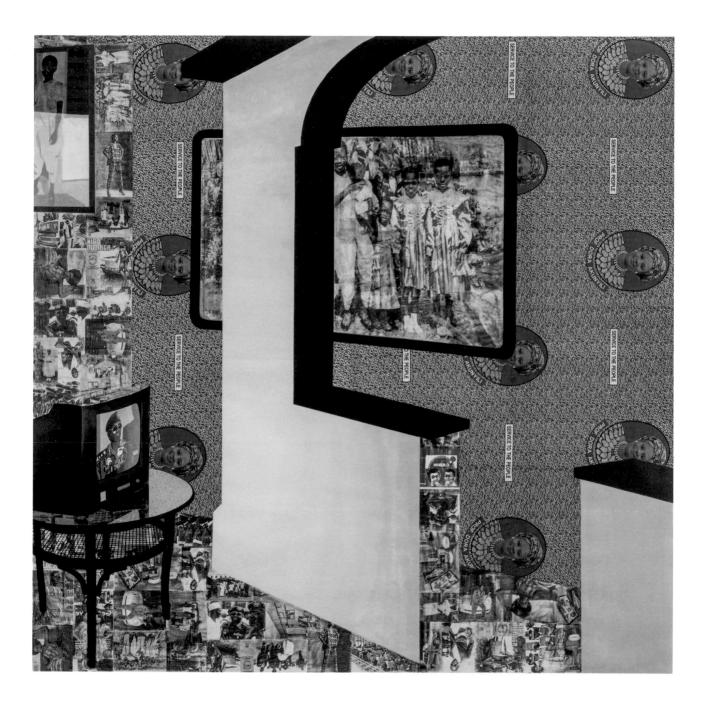

Exhibition Checklist

I Refuse to be Invisible, 2010
Ink, charcoal, acrylic, and transfers
on paper
120 x 84 in. (304.8 x 213.4 cm)
Collection Jack and Connie Tilton

Nyado: The Thing Around Her Neck, 2011
Charcoal, acrylic, colored pencils, lace,
collage, and transfers on paper
84 x 84 in. (213.4 x 213.4 cm)
Courtesy the artist

5 Umezebi Street, New Haven, Enugu, 2012
Acrylic, charcoal, pastel, colored pencils,
and transfers on paper
84 x 105 in. (213.4 x 266.7 cm)
Collection Craig Robins

*I Always Face You, Even When It Seems
Otherwise*, 2012
Charcoal, acrylic, and transfers on paper
2 panels, each 78 x 78 in.
(198.12 x 198.12 cm)
Courtesy of the Pennsylvania Academy
of the Fine Arts, Philadelphia. Museum
Purchase

Janded, 2012
Acrylic, oil, and collage on canvas
24 x 20 in. (61 x 50.8 cm)
Private collection

Nwantinti, 2012
Acrylic, charcoal, colored pencils, collage,
and transfers on paper
68 x 96 in. (172.7 x 243.8 cm)
The Studio Museum in Harlem; Museum
purchase with funds provided by the
Acquisition Committee and gift of the artist

Thread, 2012
Acrylic, charcoal, pastel, colored pencils,
and transfers on paper
52 x 52 in. (132 x 132 cm)
Private collection

For Services – Victoria Regina, 2013
Oil, acrylic, and collage on canvas
24 x 20 in. (61 x 50.8 cm)
Private collection

*"The Beautyful Ones Are Not Yet Born"
Might Not Hold True For Much Longer*, 2013
Acrylic and transfers on paper
64 x 82 7/8 in. (162.6 x 210.5 cm)
Nasher Museum of Art at Duke University;
Promised gift of Marjorie and Michael
Levine

Tea Time in New Haven, Enugu, 2013
Acrylic, collage, colored pencils, charcoal,
and transfers on paper
84 x 111 in. (213.4 x 281.9 cm)
Private collection, Courtesy Marianne
Boesky Gallery, New York

"The Beautyful Ones" Series #1c, 2014
Acrylic, colored pencils, and transfers on
paper
61 x 42 in. (154.9 x 106.7 cm)
Courtesy the artist and Victoria Miro,
London

Bush Girl, 2015
Acrylic, colored pencils, and transfers on
paper
84 x 84 in. (213.4 x 213.4 cm)
Courtesy the artist and Victoria Miro,
London

I See You In My Eyes, 2015
Acrylic, transfers, colored pencils, collage,
and commemorative fabric on paper
84 x 84 in. (213.4 x 213.4 cm)
Courtesy the artist and Victoria Miro,
London

I Still Face You, 2015
Acrylic, colored pencils, charcoal, oil,
and transfers on paper
83 1/4 x 104 3/4 in. (211.5 x 266.1 cm)
Los Angeles County Museum of Art,
Purchased with funds provided by
AHAN: Studio Forum, 2015 Art Here
and Now purchase

Sisi eko, 2015
Acrylic and oil on panel
20 x 24 in. (61 x 50.8 cm)
Courtesy the artist and Victoria Miro,
London

"The Beautyful Ones" Series #4, 2015
Acrylic, colored pencils, and transfers
on paper
61 x 42 in. (154.9 x 106.7 cm)
Courtesy the artist and Victoria Miro,
London

Chronology KRISTEN RUDY

1983
Born in Enugu, Nigeria, to Dr. J.C. Akunyili, a surgeon, and Dr. Dora Nkem Akunyili, a professor of pharmacology; fourth of six siblings

1993–1999
Attends all-girls boarding school in Lagos, Nigeria

1999
To augment her Nigerian education, moves to Pennsylvania to study at the Community College of Philadelphia as part of a traditional gap year between high school and college; studies painting for the first time

2000–2004
Attends Swarthmore College, Pennsylvania, and earns a bachelor of arts with honors in biology and studio art

2001
Mother, Dr. Dora Nkem Akunyili, becomes director general of Nigerian National Agency for Food and Drug Administration and Control

2003
Receives Jonathan Altman Art Grant, Swarthmore College

2006
Completes post-baccalaureate certificate at Pennsylvania Academy of Fine Arts, Philadelphia, seeking out acclaimed Realist painter Sidney Goodman as a professor and mentor; learns traditional Western painting and drawing technique

2007–2009
Continues attending painting and drawing classes in the certificate program of Pennsylvania Academy of the Fine Arts, while developing her studio practice

2008
Mother becomes Nigerian Minister of Information and Communications; serving for two years in this position, she spearheads popular "Re-branding Nigeria" campaign, an attempt to change the international perception of Nigeria
Receives Fellowship Juried Prize, Pennsylvania Academy of the Fine Arts

2009
Marries American Justin Crosby and moves to New Haven, CT

2009–2011
Earns master's of fine arts from Yale University; studies with Robert Reed, Rochelle Feinstein, Peter Halley, and Sam Messer; receives core crits from Coco Fusco, Carroll Dunham, Lyle Ashton Harris, and Mickalene Thomas; begins experimenting with transferred images

2010
Receives Gamblin Painting Prize, Yale University

2011
Receives Carol Schlosberg Memorial Prize for Excellence in Painting, Yale University

2011–2012
Accepted into prestigious artist-in-residence program at The Studio Museum in Harlem, New York, NY, along with Xaviera Simmons and Meleko Mokgosi

2013
Receives Rosenthal Family Foundation Award in Painting—given to a "young American painter of distinction"—from the American Academy of Arts and Letters
Artwork is used by David Byrne's music label, Luaka Bop, for vinyl compilation set of famous Nigerian electro funk artist William Onyeabor

2014
Moves to Los Angeles, CA
Receives Smithsonian American Art Museum's James Dicke Contemporary Artist Prize, which recognizes an artist younger than 50 who has produced a significant body of work and consistently demonstrates exceptional creativity; selected by a panel of esteemed jurors, including Thelma Golden, director and chief curator, The Studio Museum in Harlem; Byron Kim, artist; Harry Philbrick, Edna S. Tuttleman Director, The Museum at Pennsylvania Academy of the Fine Arts; Walter Robinson, artist, critic, and founding editor, *Artnet Magazine;* Sheena Wagstaff, Leonard A. Lauder Chairman of Modern and Contemporary Art, The Metropolitan Museum of Art; in addition to Akunyili Crosby, the 2014 nominees were Cory Arcangel, Trisha Baga, Paul Chan, Barnaby Furnas, Theaster Gates, KAWS (Brian Donnelly), Josiah McElheny, Dave McKenzie, Julie Mehretu, Frances Stark, Swoon (Caledonia Curry), and Mickalene Thomas
Mother passes away after prolonged battle with cancer

2015
Included in New Museum's Third Triennial, *Surround Audience*, curated by Lauren Cornell and Ryan Trecartin
First solo exhibitions in Los Angeles open at the Hammer Museum and Art + Practice
Honored with the Joyce Alexander Wein Artist Prize, given by The Studio Museum in Harlem, recognizing established or emerging African-American artists
Receives Next Generation Honor from New Museum, New York, NY
Commissioned by the Whitney Museum of American Art to create a public art installation for its billboard space overlooking the High Line in New York, NY

2016
Njideka Akunyili Crosby: I Refuse to be Invisible, her premiere solo survey exhibition, opens at the Norton Museum of Art, West Palm Beach, FL

Exhibition History KRISTEN RUDY

Solo and Two-Person Exhibitions
2016
Njideka Akunyili Crosby: I Refuse to be Invisible, Norton Museum of Art, West Palm Beach, FL

2015
Njideka Akunyili Crosby: The Beautyful Ones, Art + Practice, Los Angeles, CA
Hammer Projects: Njideka Akunyili Crosby, Hammer Museum, Los Angeles, CA

2013
I Always Face You, Even When it Seems Otherwise, Two-Person Show with Simone Leigh, Tiwani Contemporary, London, UK
Domestic Experiences, Foreign Interiors, Two-Person Show with Doron Langberg, Sensei Exchange, New York, NY
I Still Face You, Franklin Art Works, Minneapolis, MN
New Works, Two-Person Show with Abigail DeVille, Gallery Zidoun, Luxembourg

2012
Art Statements, Tilton Gallery, Art Basel 43, Basel, Switzerland

Selected Group Exhibitions
2015
Portraits and Other Likenesses from SFMOMA, Museum of the African Diaspora, San Francisco, CA
Surround Audience, 2015 New Museum Triennial, curated by Lauren Cornell and Ryan Trecartin, New Museum, New York, NY

2014
Kings County, Stevenson Gallery, Cape Town, South Africa
Summer Shuffle: Contemporary Art @ PAFA Remixed, Pennsylvania Academy of the Fine Arts, Philadelphia, PA
Draped Down, The Studio Museum in Harlem, New York, NY
Sound Vision: Contemporary Art from the Collection, Nasher Museum of Art at Duke University, Durham, NC
Meeting in Brooklyn, curated by Monica Lenaers, Landcommandery of Alden-Biesen, Bilzen, Belgium
Shakti, Brand New Gallery, Milan, Italy

2013
Housewarming, curated by Elizabeth Ferrer, BRIC, Brooklyn, NY
Jump Cut, Marianne Boesky Gallery, New York, NY
Bronx Calling: The Second Bronx Biennial, The Bronx Museum of the Arts, Bronx, NY
Cinematic Visions: Paintings at the Edge of Reality, curated by James Franco, Isaac Julien, and Glenn Scott Wright, Victoria Miro Gallery, London, UK
Exhibition of Works by Newly Elected Members and Recipients of Honors and Awards, American Academy of Arts and Letters, New York, NY
Invitational Exhibition of Visual Arts, American Academy of Arts and Letters, New York, NY

2012
Primary Sources, The Studio Museum in Harlem, New York, NY
Waiting For The Queen, Diker Gallery, Brooklyn Academy of Music, Brooklyn, NY
LOST and FOUND: Belief and Doubt in Contemporary Pictures, Museum of New Art, Detroit, MI
Group Show, Clifford Chance USA, New York, NY
Configured, curated by Teka Selman, Benrimon Contemporary, New York, NY

2011
The Bearden Project, The Studio Museum in Harlem, New York, NY
Collage Perspectives, Swarthmore College List Gallery, Swarthmore, PA
Paperwork, curated by Nina Chanel Abney, Kravets/Wehby Gallery, New York, NY
Yale MFA Thesis Show, Green Gallery, New Haven, CT
CAA New York Area MFA Exhibition, Hunter College Times Square Gallery, New York, NY

2010
Yale University Class of 2011 Show, Green Gallery, New Haven, CT

2009
Yale University 1st Year Graduate Show, Green Gallery, New Haven, CT

Residencies and Awards
2014
James Dicke Contemporary Artist Prize, The Smithsonian American Art Museum, Washington, DC

2013
The Space Program of The Marie Walsh Sharpe Art Foundation, New York, NY
Rosenthal Family Foundation Award, American Academy of Arts and Letters, New York, NY
International Studio and Curatorial Program, sponsored by the Edward and Sally Van Lier Fund of the New York Community Trust, New York, NY
Rema Hort Mann Foundation Grant
Artist in the Marketplace, The Bronx Museum of the Arts, Bronx, NY

2012
Acadia Summer Arts Program, Acadia, ME

2011
Carol Schlosberg Memorial Prize for Excellence in Painting, Yale University, New Haven, CT
Artist-in-Residence, The Studio Museum in Harlem, New York, NY

2010
Gamblin Painting Prize, Yale University, New Haven, CT

2009
The Coverley-Smith Prize, Woodmere Art Museum, Philadelphia, PA

2003
Jonathan Altman Art Grant, Swarthmore College, Swarthmore, PA

Public Collections
Yale University Art Gallery, New Haven, CT
Pennsylvania Academy of the Fine Arts, Philadelphia, PA
Studio Museum in Harlem, New York, NY
San Francisco Museum of Modern Art, San Francisco, CA
Nasher Museum of Art at Duke University, Durham, NC
Tate Gallery, London, UK
The New Church Museum, Cape Town, South Africa
Los Angeles County Museum of Art, Los Angeles, CA

Selected Bibliography KRISTEN RUDY

Books and Exhibition Catalogues

2015

Cornell, Lauren, and Helga Christoffersen, ed. *Surround Audience: New Museum Triennial 2015.* New York: Skira Rizzoli Publications, Inc., 2015.

2013

Baptist, Stephanie, ed. *Njideka Akunyili & Simone Leigh: I Always Face You, Even When it Seems Otherwise.* London: Tiwani Contemporary, 2013.

Merjian, Ara H. *Vitamin D2.* London: Phaidon, 2013.

The Bronx Museum of the Arts. *Bronx Calling: The Second AIM Biennial.* New York: The Bronx Museum of the Arts, 2013.

Articles and Reviews

2015

Bradley, Paige K., "The Great Escape," artforum.com. *ArtForum,* 26 February 2015. http://artforum.com/diary/id=50427

Budick, Ariella, "2015 Triennial: Surround Audience, New Museum, New York – review," ft.com. *The Financial Times,* 10 March 2015. http://www.ft.com/cms/s/0/e5584b9e-c67b-11e4-a13d-00144feab7de.html#axzz3V1tbU2gB

Burns, Charlotte, "New Museum's Generational Triennial: Wired for the Future," theguardian.com. *The Guardian,* 25 February 2015. http://www.theguardian.com/artanddesign/2015/feb/25/new-museum-generational-triennial-wired-future

Cotter, Holland, "Review: New Museum Triennial Casts a Wary Eye on the Future," nytimes.com. *The New York Times,* 26 February 2015. http://www.nytimes.com/2015/02/27/arts/design/review-new-museum-triennial-casts-a-wary-eye-on-the-future.html?_r=0

Dedieu, Jean-Philippe, "Njideka Akunyili Crosby's Intimate Universes," newyorker.com. *The New Yorker,* 5 November 2015. http://www.newyorker.com/culture/photo-booth/njideka-akunyili-crosbys-intimate-universes

Foreign Policy, "Foreign Policy's Leading 100 Global Thinkers of 2015: Njideka Akunyili Crosby: For Collaging The Immigrant Experience," foreignpolicy.com. *Foreign Policy,* Nov/Dec 2015. http://2015globalthinkers.foreignpolicy.com/#!artists/detail/crosby

Goldberg, Roxanne, "Njideka Akunyili Crosby's Intimate Scenes of Domestic Life," hifructose.com. *Hi-Fructose Magazine,* 8 October 2015. http://hifructose.com/2015/10/08/njideka-akunyili-crosbys-intimate-scenes-of-domestic-life/

Goldstein, Andrew M., "A Theoretical Cheat Sheet to the New Museum Triennial," artspace.com. *ArtSpace Magazine,* 22 February 2015. http://www.artspace.com/magazine/interviews_features/a-theoretical-cheat-sheet-to-the-new-museum-triennial-52632

Guiducci, Mark, "Vanessa Traina Snow, Wangechi Mutu, Nicola Vassell, and More at the New Museum Next Generation Dinner," vogue.com. *Vogue,* 9 November 2015. http://www.vogue.com/13369460/vanessa-victoria-traina-proenza-schouler-new-museum-next-generation-dinner-party-2015/

Jansen, Charlotte, "Njideka Akunyili Crosby's intimate tableaus echo her transnational world," wallpaper.com. *Wallpaper,* 23 November 2015. http://www.wallpaper.com/art/njideka-ankunyili-crosby-hammer-museum

Kennedy, Randy, "Wein Prize Is Awarded to a Nigerian-born Artist," nytimes.com. *The New York Times,* 26 October 2015. http://artsbeat.blogs.nytimes.com/2015/10/26/wein-prize-is-awarded-to-a-nigerian-born-artist/?_r=0

Lehrer, Adam, "Six Pieces That Stuck Out at the New Museum's Triennial," forbes.com. *Forbes,* 25 February 2015. http://www.forbes.com/sites/adamlehrer/2015/02/25/six-pieces-that-stuck-out-at-the-new-museums-triennial/

McGroarty, Patrick, "Africans Turn to Local Art: Five Artists to Watch," wsj.com. *The Wall Street Journal,* 13 March 2015. http://www.wsj.com/articles/africans-turn-to-local-art-five-artists-to-watch-1426261310?tesla=y

Miranda, Carolina A., "Black women artists in L.A. museums: Good news at Hammer, but representation remains weak," latimes.com. *The Los Angeles Times,* 20 July 2015. http://www.latimes.com/entertainment/arts/miranda/la-et-cam-njideka-akunyili-crosby-hammer-museum-20150718-column.html

Mongezeleli Joja, Athi, "Infinite Possibilities: Interview with Artist Njideka Akunyili," contemporaryand.com. *Contemporary And,* 5 January 2015. http://www.contemporaryand.com/blog/magazines/infinite-possibilities-interview-with-artist-njideka-akunyili/

Rosen, Miss, "Exhibit/Hammer Projects: Njideka Akunyili Crosby," craveonline.com. *Crave,* 31 October 2015. http://www.craveonline.com/art/917741-exhibit-hammer-projects-njideka-akunyili-crosby

Russeth, Andrew, "The 2015 New Museum Triennial is a Pointed, Bracing Survey of Now," artnews.com. *Art News,* 25 February 2015. http://www.artnews.com/2015/02/25/the-2015-new-museum-triennial-is-a-pointed-bracing-survey-of-now/

Slenske, Michael N., and Pernilla Holmes, "8 Incredible Artists on the Rise," architecturaldigest.com. *Architectural Digest,* 10 November 2015. http://www.architecturaldigest.com/gallery/artists-on-the-rise

Tauer, Kristen, "New Museum Honors Emerging Artists at Next Generation Dinner," wwd.com. *Women's Wear Daily,* 8 November 2015. http://wwd.com/eye/parties/new-museum-next-generation-dinner-bathouse-studios-10275469/

Valentine, Victoria L., "LaToya Ruby Frazier, Njideka Akunyili Crosby and Kalup Linzy Discuss Met Museum Works that Inspire Them," culturetype.com. *Culture Type,* 22 September 2015. http://www.culturetype.com/2015/09/22/latoya-ruby-frazier-njideka-akunyili-crosby-and-kalup-linzy-discuss-met-museum-works-that-inspire-them/

Valentine, Victoria L., "Studio Museum Awards 2015 Wein Artist Prize to Njideka Akunyili Crosby," culturetype.com. *Culture Type,* 28 October 2015. http://www.culturetype.com/2015/10/28/studio-museum-awards-2015-wein-artist-prize-to-njideka-akunyili-crosby/

Walsh, Brienne, "The 2015 New Museum Triennial: Not So Charmed," christies.com. *Christie's,* 26 February 2015. http://www.christies.com/features/New_Museum_Triennial-5716-1.aspx

2014

Burns, Charlotte and Anny Shaw, "Seek and ye shall find," *The Art Newspaper,* Art Basel Miami Beach Daily Edition, 6–7 December 2014: 2.

Chinedu, Okoro, "Nigeria: Akunyili Crosby Wins Top U.S. Arts Award," allafrica.com. *All Africa online,* 26 November 2014. http://allafrica.com/stories/201411270463.html

Duray, Dan, "Njideka Akunyili Crosby Awarded Smithsonian's 2014 James Dicke Prize," *ArtNews,* 25 November 2014.

Fawcett, Kirstin, "Njideka Akunyili Crosby's Intimate Work Straddles Mediums and Oceans," smithsonianmag.com. *Smithsonian,* 1 December 2014. http://www.smithsonianmag.com/smithsonian-institution/njideka-akunyili-crosby-award-winning-work-straddles-mediums-and-worlds-180953474/

Frank-Edet, Judith, "Dora Akunyili's Daughter Wins American Art Museum 2014 Prize," *Daily Times Nigeria,* 29 November 2014.

McGlone, Peggy, "Painter Njideka Akunyili Crosby wins $25,000 American Art Museum prize," *The Washington Post,* 25 November 2014.

Ong, Amandas, "Showcase: Njideka Akunyili," *Elephant,* Issue 17 (Winter 2013-14): 20-25.

Scheffler, Daniel, "Brooklyn Inspires African Artists," nytimes.com. *The New York Times,* 14 October 2014. http://nyti.ms/1rsr4SC

Smee, Sebastian, "Many techniques, much to ponder, in 'Rest of Her Remains,'" *The Boston Globe,* 4 March 2014.

Umukoro, Sam, "Njideka Akunyili-Crosby – Chimamanda of the Art World?" *Vanguard,* 9 November 2014.

2013

Abbe, Mary. "Minneapolis gallery showcases rising star Njideka Akunyili," startribune.com. *Minneapolis Star Tribune,* 27 June 2013. http://www.startribune.com/minneapolis-gallery-showcases-rising-star-njideka-akunyili/213357711/

Momodu, Loren Hansi, "Njideka Akunyili: The Beautyful Ones," contemporaryand.com. *Contemporary And,* Fall 2013. http://www.contemporaryand.com/blog/magazines/njideka-akunyili-the-beautyful-ones/

Steinhauer, Jillian, "Getting an International Glimpse at Open Studios," hyperallergic.com. *Hyperallergic,* 30 April 2013. http://hyperallergic.com/69961/getting-an-international-glimpse-at-open-studios/

Thomas, Kuoure, "Feast for the Eyes: Red Rooster Harlem's Recipe for Art," *ARTnews,* 20 February 2013.

Wyatt, Daisy, "Things fall into two parts: Artist Njideka Akunyili tells a new Nigerian story," independent.co.uk. *The Independent,* 17 October 2013. http://www.independent.co.uk/arts-entertainment/art/features/things-fall-into-two-parts-artist-njideka-akunyili-tells-a-new-nigerian-story-8887283.html

2012

Copley, Caroline, "Art Basel tests buyers' instincts in time of crisis," reuters.com. *Reuters,* 12 June 2012. http://www.reuters.com/article/2012/06/13/uk-arts-basel-idUSLNE85C01E20120613

Cotter, Holland, "'Primary Sources': 'Artists in Residence 2011-12,'" nytimes.com. *The New York Times,* 19 July 2012. http://nyti.ms/MympB1

Davies, Catriona, "Artist joins Nigeria's 'cultural explosion,'" cnn.com. *CNN Online,* 23 October 2012. http://www.cnn.com/2012/10/22/world/africa/nigerian-artist-njideka-akunyili/

Elliott, Bobby, "*Primary Sources,* The Studio Museum's Annual Artists in Residence Exhibition," huffingtonpost.com. *The Huffington Post,* 17 June 2012. http://www.huffingtonpost.com/bobby-elliott/the-studio-museum-primary-sources_b_1602517.html

Fialho, Alex, "'Primary Sources' at The Studio Museum in Harlem," artfcity.com. *Art Fag City,* 17 October 2012. http://artfcity.com/2012/10/17/primary-sources-at-the-studio-museum-in-harlem/

Fine, Bill and Benjamin Sutton, "Tilton Gallery Sells Out Art Basel Booth of Njideka Akunyili Collages in Half an Hour," *Artinfo,* 18 June 2012.

Mokgosi, Meleko, Xaviera Simmons and Njideka Akunyili, "In the Studio with the 2011–12 Artists in Residence," *Studio Magazine,* Summer/Fall 2012: 8–15.

Odufunade, Bomi, "Primary Colors: Njideka Akunyili," *Arise Magazine,* 24 August 2012.

Ossei-Mensah, Larry, "Collage Graduate," *Arise Magazine,* October 2012: 36.

2011

Cotter, Holland, "A Griot for a Global Village," nytimes.com. *The New York Times,* 8 December 2011. http://www.nytimes.com/2011/12/09/arts/design/romare-bearden-at-studio-museum-schomburg-and-the-met.html

Elliott, Bobby, "The Bearden Project: A Family Affair," huffingtonpost.com. *The Huffington Post,* 7 December 2011. http://www.huffingtonpost.com/bobby-elliott/the-bearden-project-a-fam_b_1132871.html

Garza, Evan J., ed., "MFA Annual #93, 2011," *New American Paintings,* April/May 2011.

Newhall, Edith, "Painterly Collages," *The Philadelphia Inquirer,* 27 November 2011.

Smith, Paul, "Uptown Celebrates 100 Years of Bearden, Harlem's True Renaissance Man," theuptowner.org. *The Uptowner,* 15 December 2011. http://archives.jrn.columbia.edu/2012-2013/theuptowner.org/2011/12/15/uptown-celebrates-100-years-of-bearden-harlem%E2%80%99s-%E2%80%98true-renaissance-man%C2%80%99/index.html

Zevitas, Steven, "Tomorrow's Art Stars Today: New American Paintings Presents the MFA Annual," huffingtonpost.com. *The Huffington Post,* 17 April 2011. http://www.huffingtonpost.com/steven-zevitas/tomorrows-art-stars-today_b_846158.html

2010

McComic, Katherine, "The Study of Art," *Yale Daily News,* 12 October 2010.

This publication accompanies the exhibition *Njideka Akunyili Crosby: I Refuse to be Invisible,* organized by Cheryl Brutvan, Director of Curatorial Affairs, Curator of Contemporary Art, Norton Museum of Art, January 28–April 24, 2016. This exhibition is the fifth of RAW—Recognition of Art by Women—made possible by the Leonard and Sophie Davis Fund / MLDauray Arts Initiative.

Editor: Wendy Bernstein
Designer: Bethany Johns
Printer: Meridian Printing
© 2016 Norton Museum of Art, West Palm Beach, Florida.

"Bye-Bye, Babar (Or: What is an Afropolitan?)" by Taiye Selasi, originally published in *The LIP Magazine*. Copyright © 2005 by Taiye Selasi, used by permission of The Wylie Agency, LLC.

Norton Museum of Art
1451 South Olive Avenue
West Palm Beach, Florida 33401
(561) 832-5196
www.norton.org